SPACES FOR SPIRIT

ADORNING THE CHURCH

NANCY CHINN

LITURGY TRAINING PUBLICATIONS

This book was designed by M. Urgo, typeset in Garamond and Quay by Jim Mellody-Pizzato, and printed in the USA by Quebecor Printing Book Group. David Philippart was the editor. All photos are by Nancy Chinn, except for the following: photos on plates 2, 3 by Robin Chinn; photos on plates 21, 22 by Jann Weaver; photo on plate 34 by Hetty Loudwick; photos on plates 38, 39 by Jeffrey G. Smith.

SPACES FOR SPIRIT © 1998, Archdiocese of Chicago: Liturgy Training Publications, 1800 North Hermitage Avenue, Chicago IL 60622-1101; 1-800-933-1800; orders@ltp.org; fax 1-800-933-7094. All rights reserved.

Library of Congress Catalog Card Number 98-85925

ISBN 1-56854-242-9

SPACES

03 02 01 00 6 5 4 3 2

LITURGY
TRAINING
PUBLICATIONS

CONTENTS

PREFACE

It was Easter Sunday. I went to the early service to avoid crowds and sat under the balcony near the back of the church. The day was rainy, so the church was darker than usual, cave-like under the low ceiling. It was hard to hear, hard to see.

The pastors each wore their black Geneva gowns adorned with white catalog stoles, and there was something white, dirty and torn on the pulpit in the front. That was the Easter look, except for twenty-five potted lilies placed in a single row across the chancel steps, waiting for their delivery during the next week to shut-ins. Every one of them was closed, still in bud.

The choir sang its cheery songs, the organ was glorious and we sang powerful hymns of hope. The readings and lessons were forgettable within minutes. But the space itself spoke volumes. It said, "Life as usual! Stay safe! Pay attention to the words! Stay numb!"

I left, muttering my discomfort to my pastors, who, to my surprise, called me the next week. "We don't understand what you were talking about, but it sounded interesting. Could you work with us?"

I didn't know what to do — until Advent. The church was sponsoring two Ethiopian men through immigration and I was taking a class on symbols. Our assignment was to choose a symbol that we did not understand, research it, make some art about it and teach it to our class. I had chosen angels, because they seemed trivial to me, romantic and relegated (in those days) to Christmas cards. I had a book on Ethiopian angels, and when the two men had their turn at my house for dinner, I showed it to them. The images were powerful. But it was the men's faces, lit up with joy as they told me this was what they believed, that showed me what to do. In this way, my work for the church began.

My first attempts to make these angels were wrong. Listening to me try to resign, the pastor did not tell me what to do. He asked me lots of questions: What didn't I like about my work, and what could I do about it? He helped me tap my own intuitive knowledge about how to create something for that space.

I went away, painted the angels and brought them back. (See plate 35 and the photo on page 20.) But how could I hang them? He knew just the right person, he said, a retired carpenter. Together we made the angels fly. Right away I learned that making the art work involved many skills, some of which I did not have. As soon as the work was up, people came to me. They asked: How can we help you do some more work? I knew how to keep lots going on at once. Help sounded great. Several of us met with the worship planning team, listened to the Lenten ideas and then talked together about how that might look. That was almost twenty years ago.

Teaching about this work began a few years later. What you have before you are the ideas, philosophy and some methods distilled over the years. When possible, I have included pictures as well as words. I have tried to describe how an artist works within the structure of worship. My hope is that you will find this book inspiring, and that it will help make your own work more efficient.

The first chapter is about the vision of making art for worship, both from a church's and an artist's perspective. The second chapter explores some of the practical details, with abundant examples of work done in many settings. The third chapter centers on design questions and the way art makes meaning within worship. The fourth chapter talks about forming an arts committee. The fifth chapter discusses a particular medium — paper lace — and traces the development of a project from concept to execution. The last chapter ends with some encouraging thoughts and cautionary warnings.

There are many, many to thank, especially my early pastor, Roy Schlobalm, all those who attended workshops and classes and taught me the questions, all those who worked with me over the years to create and install the works pictured here, the churches who asked me to come and work with them, and especially Harriet Gleeson, whose gentle insistence has encouraged me to step out of my art life and finally write it all down. Now can I get back to my studio?

Nancy Chinn
Oakland, California

About the Plates & Photographs

Here is some additional information about the works depicted in the plates and photographs throughout the book. Note that the plates have numbers that are distinct from page numbers. Dimensions, materials and titles are usually listed beneath each illustration. Locations and patrons are listed on page 72.

Paper Lace

In the works shown in plates 2, 3 and 37 the paper has been prepared with layers of acrylic paint thinned with matte medium and water. Drawing on the reverse side allows for adjustment and correction before cutting. The photographs in plates 4 and 5 and the photographs on pages 27, 56, 60 and 61 are details of the work depicted on the cover. This large installation, done to transform a coliseum into a place of prayer for a conference, is designed to be seen from all sides. The individual pieces range in size from 3' x 15' to 9' x 25'. In the detail shown on page 60 note the monkeys, cut in positive form, and the birds and bananas, cut in negative form. The detail in plate 40 is a corner of a much larger triptych, *For the Healing of the Nations*. You can find human, animal and plant "nations" here. In the work shown in plate 34, patches from the painting shown in plate 36 were cut and glued as "tiles" on the back.

Mobiles and Canopies

The work shown in plates 21 and 22 is composed of about 25,000 origami cranes, folded in prayer for people with AIDS by the members of the Episcopal diocese of San Francisco. Five layers thick, it suggests rising prayer and descending spirit. The canopy in plates 38 and 39 is discussed in chapter two. The mylar stars in plates 6 and 32 are taped to a large "net" made from fishing line created on site and raised upon completion (see the photo on page 71 for how this is done.). Chapter five also discusses a dropline system. Acetate florist's ribbon is the material that makes up the works in the photos on pages 21 and 23. The first is woven on a frame like a table constructed of garden bamboo wrapped with lavender ribbon. The rainbow is hung from line suspended between droplines; note the detail in the front end. Nylon net is carefully painted to create the Pentecost canopies in plates 1, 23, 24 and 25, and in the photos on pages 30 and 31.

Painting on Fabric

The works in plate 35 and the photo on page 20 are discussed in the preface. They are watercolor on nylon. This is the same material used in the works shown in plates 12, 14, 15, 16, 17 and 18 but

here the completed painting is cut free from the surrounding fabric, and basted onto nylon net with 2" stitches made with invisible thread. The works in plates 10 and 11 are painted on one piece of batiste with acrylic to look dimensional. They are then cut free and stitched onto nylon net. Each represents a fragment of weaving. In plate 13, the fabric is Pellon brand non-woven interfacing fabric.

PAINTING ON PAPER

The paper used is most often photographic paper that comes in rolls. The congregation painted the papers shown in plates 6, 7 and 37 and in the photos on pages 22, 24 and 25. The triangular shapes were hung from the apex with a line along the sides of the triangle, with a stretch cord going through the hem to keep the edges taut. Weights at the ends of the cord kept tension on the stretch cord. In the work shown in plate 36, paintings were frayed at the edge and strengthened with wire to create a sense of movement. The fragments were glued onto nylon net (working upside down) and then the edge was supported by a ring of Gatorfoam® brand graphic arts panel, creating an armature with which to hang the spiral. The work in plate 19 is depicted in progress in the photographs on pages 24 and 25; note that the large scale painting is done with squeegees mounted on poles. The works in plates 8, 9, 26, 27, 28 and 29 are inspired by African textile patterns. The patterns are authentic, but the colors were changed to create a rainbow. The balcony mural in plates 30 and 31, watercolor on paper, used patterns from ethnic textiles interspersed with scenes from the life of Jesus.

FABRIC STITCHED ON FABRIC

The photos on pages 28 and 29 show pieces of an ensemble that depicts the angels of earth, air, fire and water in readings from Year C of the lectionary. Here, polyester fabric is basted on a background of netting.

MIXED MEDIA

The photo of "Lent" on page 19 shows work using most of the media discussed above. The gold crown is made of privet branches, magnolia leaves, gold adhesive paper and wire. The installation in plate 20, created for a Palm Sunday procession, uses scraps and cuttings of various papers.

PLATES

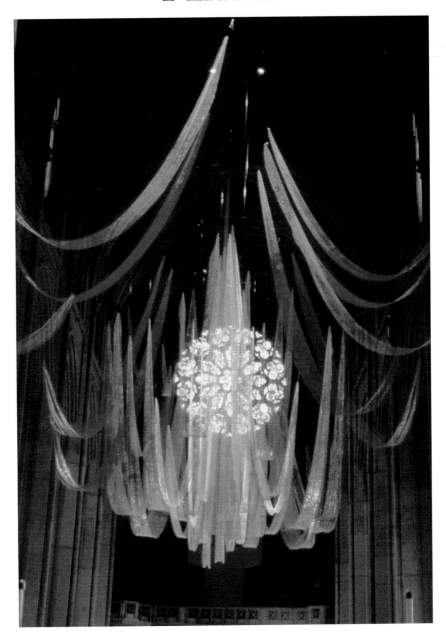

PLATE 1

PLATE 2

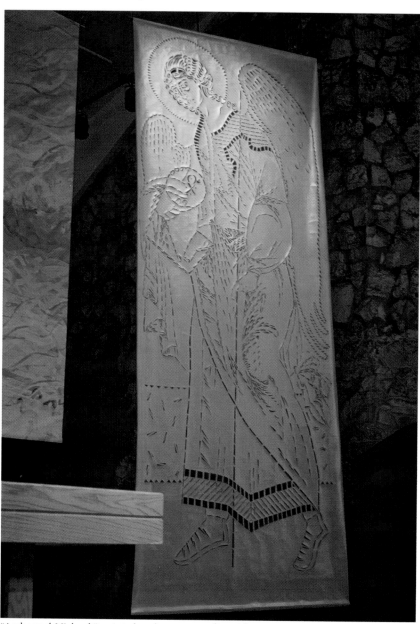

"Archangel Michael," painted and cut paper, 6' × 16'.

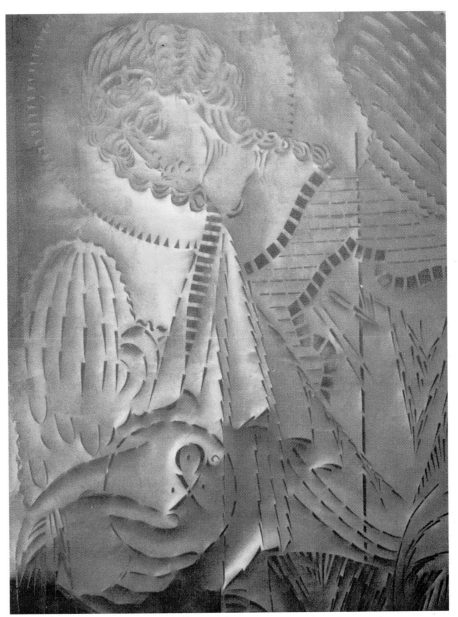

Detail.

PLATE 3

PLATE 4

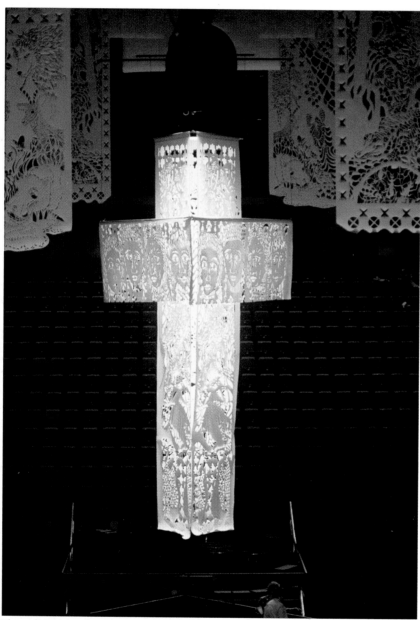

Three-dimensional cross, cut paper, 3' × 15'.

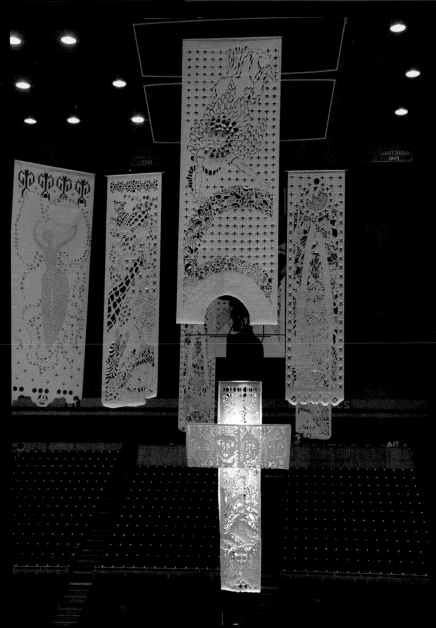

The cross in its context.

PLATE 5

Canopy of mylar stars.

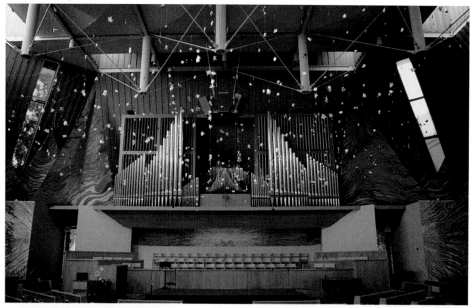

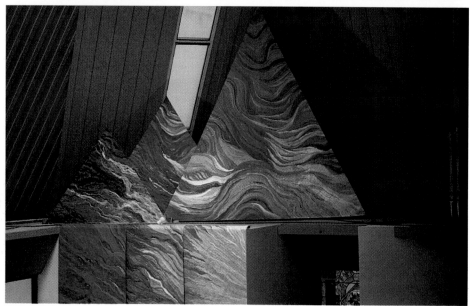

Advent paintings, detail of above installation, paint on paper, 6' × 9', 15' high.

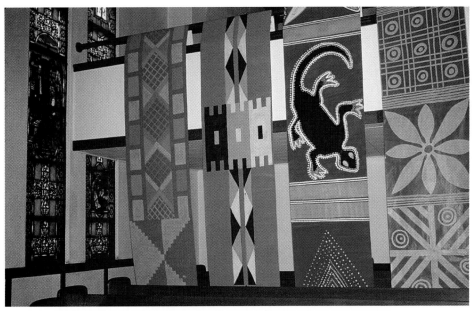

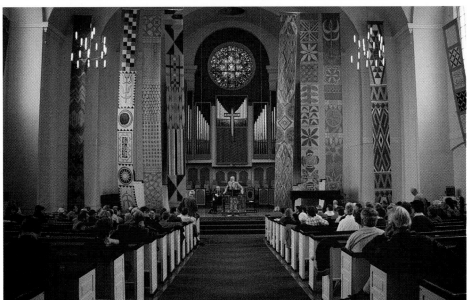

African textile patterns rendered in paint on paper, each panel 3' × 40'.

PLATES 8 & 9

PLATE 10

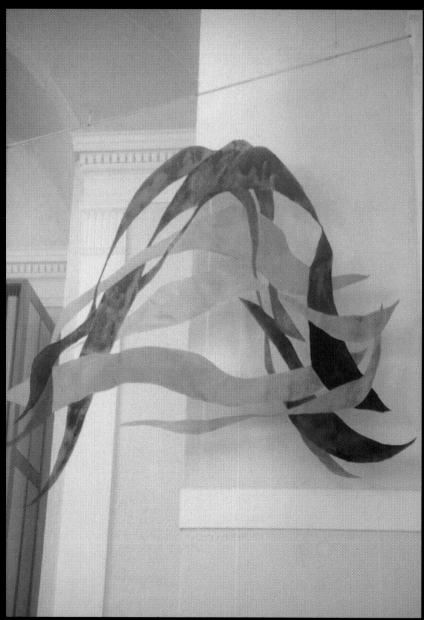

Paint on fabric, 10' × 10'.

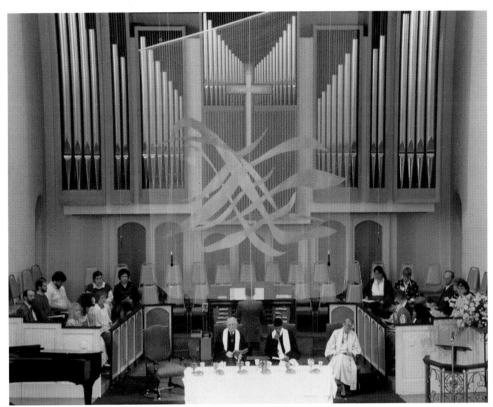

Paint on fabric, 10' × 10'.

PLATE 11

PLATE 12

Watercolor on nylon. Angel is 4' × 18' on 6' × 48' net background.

These branches, bare during Lent, were turned upside down and painted flowers added to depict Easter joy.

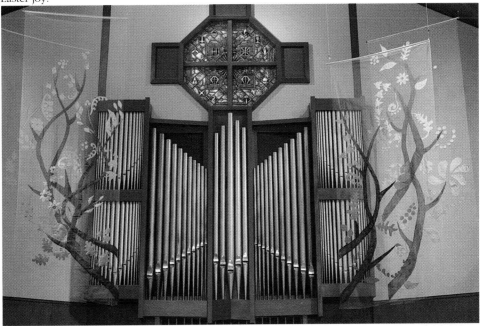

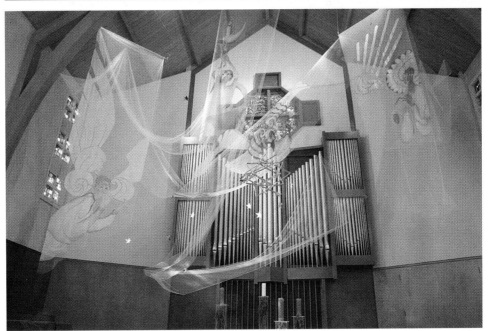

Watercolor on nylon. Each angel is approximately 4' × 18' on 6' × 48' net background.

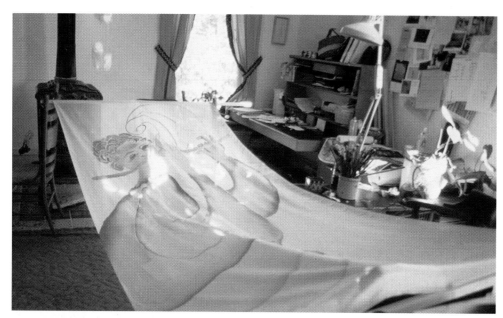

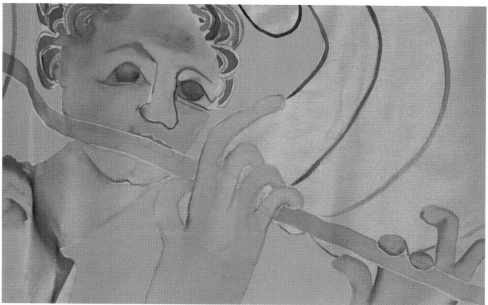

Work in progress; Watercolor on nylon.

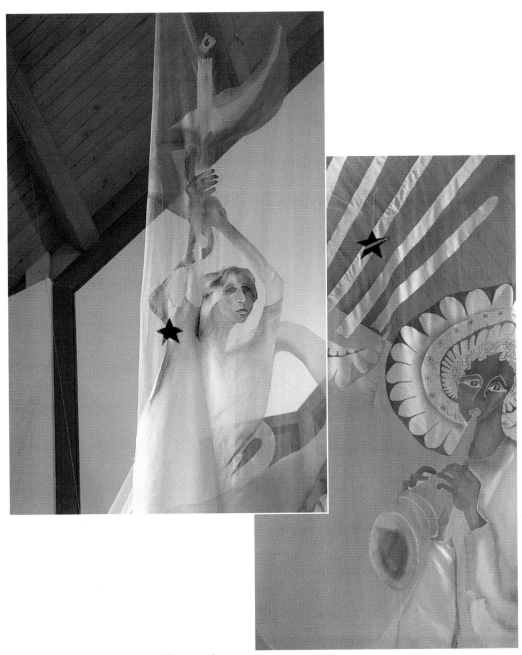

Details of finished work; watercolor on nylon.

PLATE 19

"Behold the Light," paint on paper, 10' × 32'.

"After the Parade," cut paper of various sizes.

PLATE 20

PLATE 21

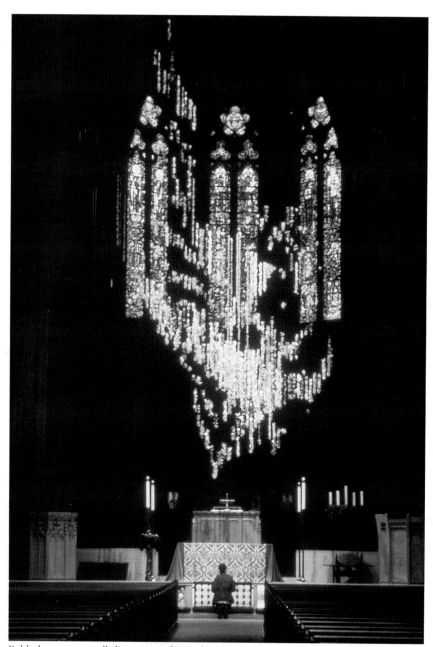

Folded paper, overall dimensions 60' × 40' × 10'.

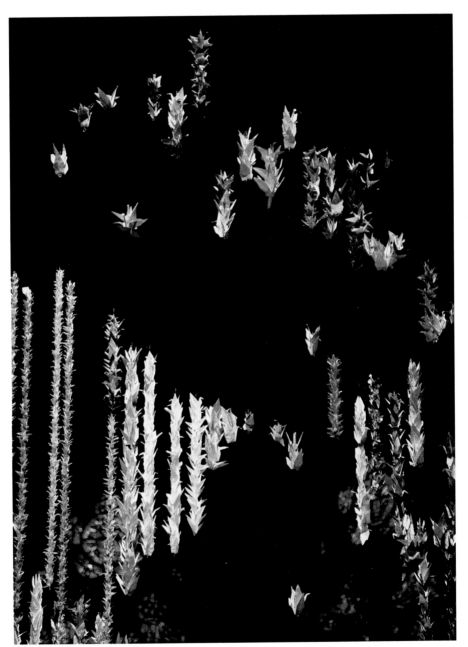

Detail.

PLATE 22

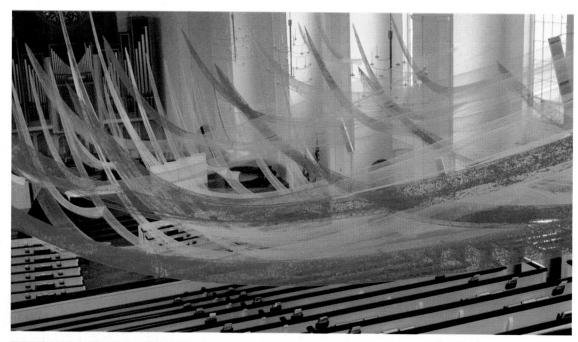

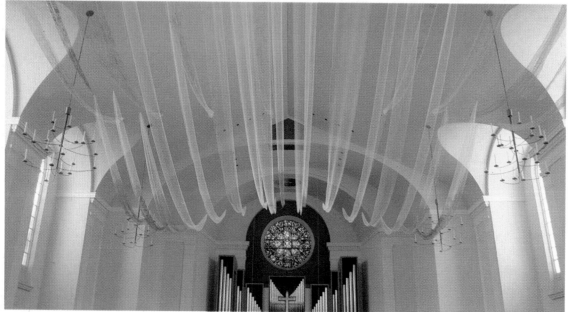

Paint on nylon, 50 strips, 18" wide, 10' to 120' long.

Detail showing how the work is attached.

PLATE 25

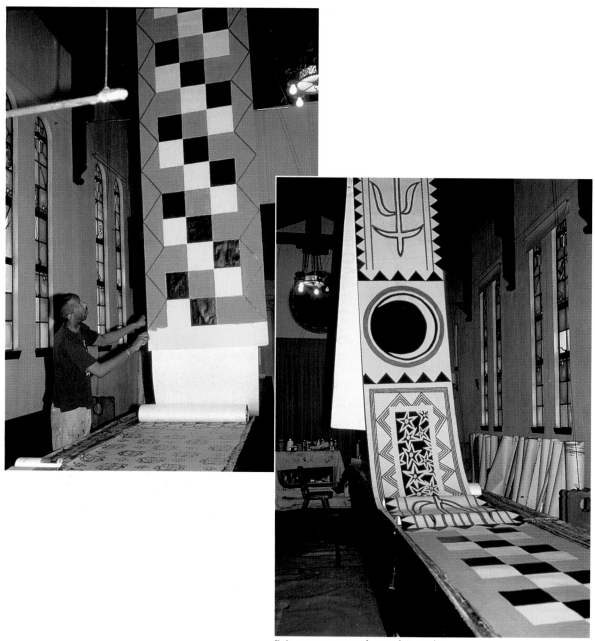

Paint on paper, each panel 3' × 40'.

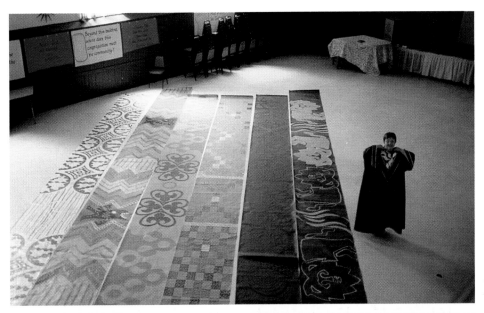

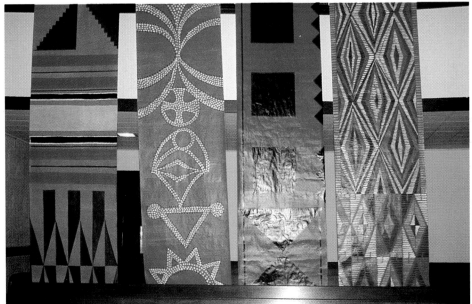

Paint on paper, each panel 3' × 40'. The author is wearing a vestment made to use with these banners.

PLATE 30

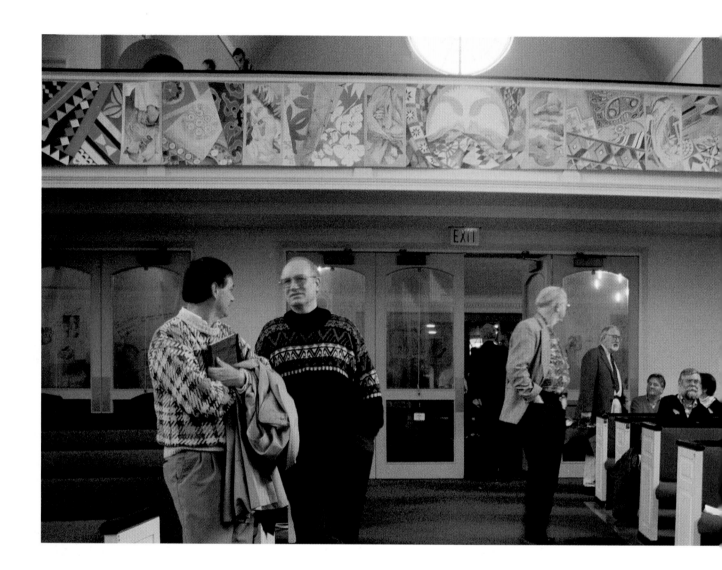

"Many Shall Believe," watercolor on paper, 32" × 480".

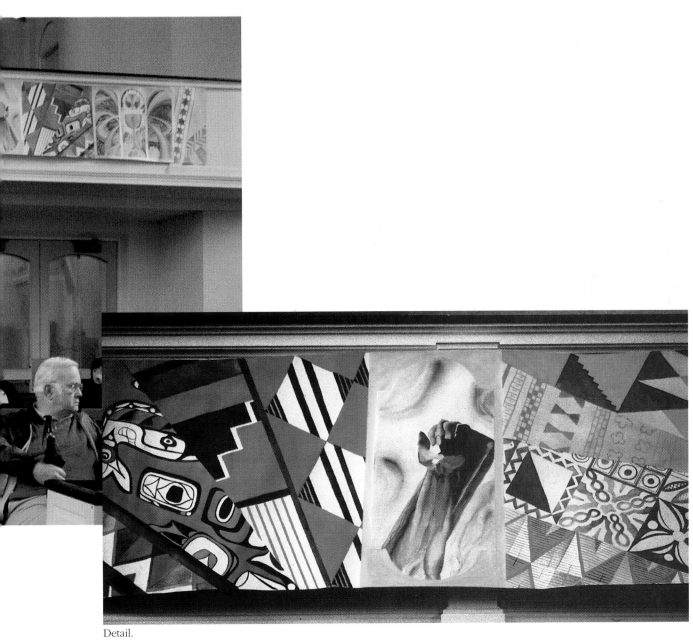

Detail.

PLATE 31

PLATE 32

Canopy of mylar stars.

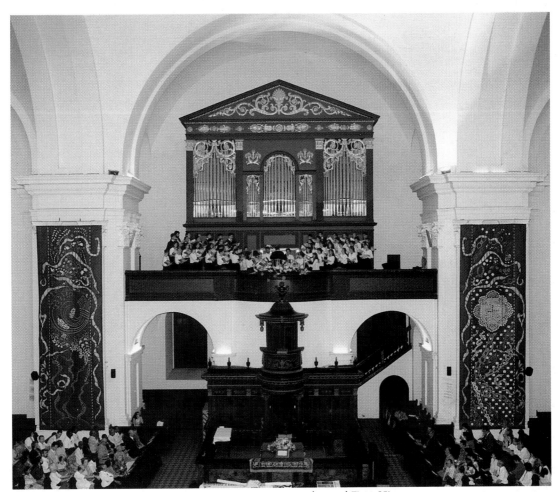

"Breaking the Chains that Bind," cut paper, paint on paper, each panel 7' × 28'.

PLATE 33

PLATE 34

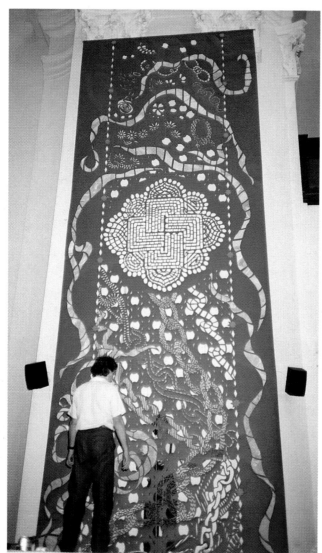

"Breaking the Chains That Bind,"
cut paper, paint on paper, 7' × 28'.

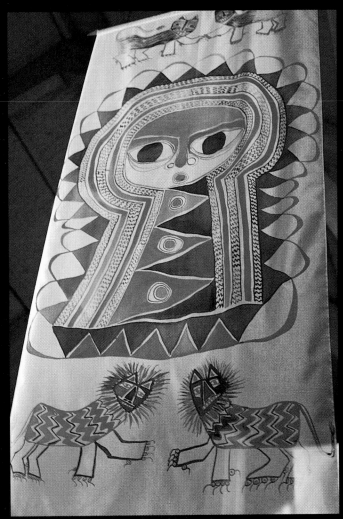

"Ethiopian Angel," watercolor on nylon, 4' × 12'.

PLATE 35

PLATE 36

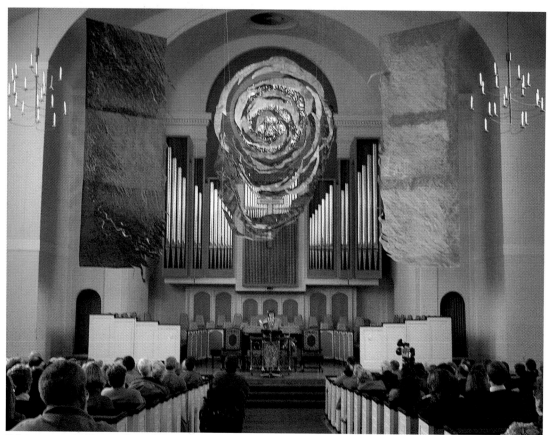

Paint on paper; side panels each 7' × 30', center piece, 9'× 25'.

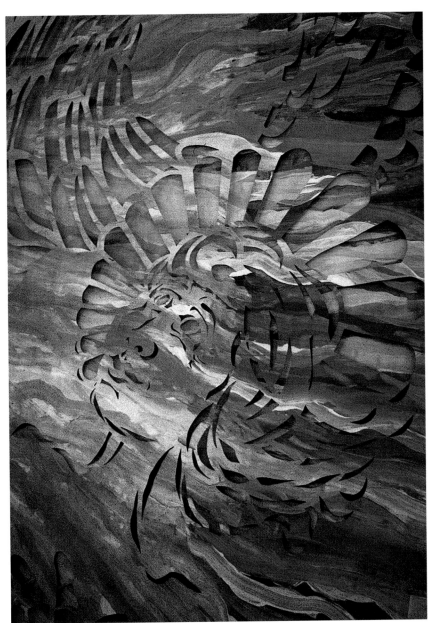

Detail, "Archangel Gabriel." Painted and cut paper, 4' × 13'.

PLATE 37

PLATE 38

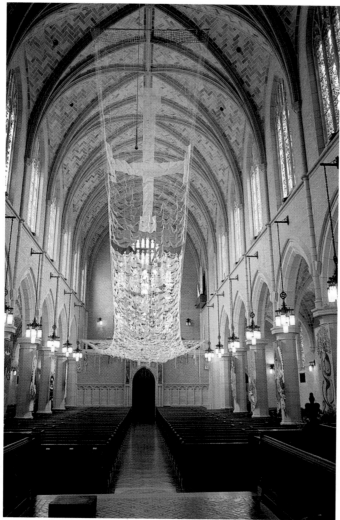

"Prayers of the People," fabric, 6' – 30' wide.

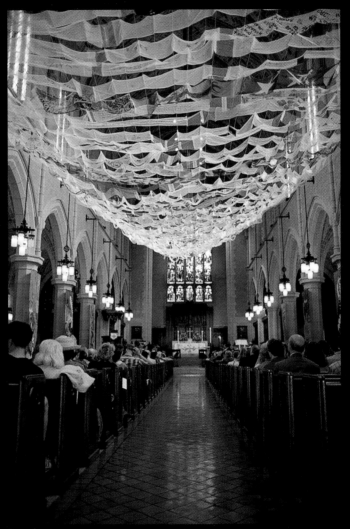

Detail.

PLATE 39

PLATE 40

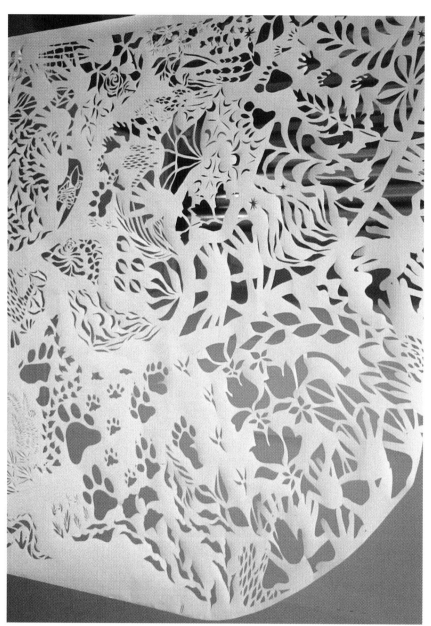

Detail of "For the Healing of the Nations." Cut paper, 3' × 4'.

1

ART, THE ARTIST AND THE CHURCH

*Then Moses said to the Israelites: See, the LORD has called by name
Bezalel, son of Uri son of Hur, of the tribe of Judah, and has
filled him with divine spirit, with skill, intelligence, and knowledge
in every kind of craft, to devise artistic designs, to work
in gold, silver and bronze, in cutting stones for setting, and in
carving wood, in every kind of craft. And he has inspired
him to teach, both him and Oholiab son of Ahisamach, of the
tribe of Dan. The LORD has filled them with skill to do every
kind of work done by an artisan or by a designer or by an
embroiderer in blue, purple and crimson yarns, and in fine linen,
or by a weaver — by any sort of artisan or skilled designer.*

Exodus 35:30 - 35

THE USE OF VISUAL ARTS

With these wise words, the Roman Catholic Bishops' Committee on the
Liturgy helps begin a discussion on art, the artist and the church: "God
does not need liturgy; people do, and people have only their own arts
and styles of expression with which to celebrate." (*Environment and
Art in Catholic Worship, #4*) Often neglected, or relegated to triviality, the visual arts are an important element of liturgy. Through visual
arts, the church proclaims and celebrates a diversity of cultures, and
expands its ability to respond to the Word of God spoken to us today.

How have visual arts been used in Christian tradition? What are
some of the hesitations and fears that we as artists and we as church
have about each other? How might an artist at the dawn of a new century create new art for the church? What does art have to do with worship or social change?

Throughout Christian history, visual art has been used to convey doctrine. Sometimes this has happened through a complex system of signs that symbolize a coded message. An example is the Christian artist's use of the Greek letters alpha and omega:

<div align="center">A Ω</div>

If you know the code, you have a shortcut to a complex theological idea. Here the visual information is not unlike a computer command in our culture: Type the code correctly and you gain access to a wide range of knowledge, like a search engine. What came to your mind when you saw those Greek letters? Did you know what this symbol meant? Can you recall where you first learned about the alpha and omega as they apply to Christ? Do you know where in the Bible this symbol comes from and why it is important to the tradition?

All these answers would have been part of the awareness of a pre-literate European Christian whose religious training was largely by oral tradition. A visual cue in the cathedral would have either brought up information that had been transmitted orally, or prompted a question about its meaning — allowing the information to be shared through a common story.

Changing Contexts

We live in a time when it is critical to seek ways to recognize a world community with its wealth of diversity. The homogenous world of European Christendom no longer exists. Some Christian symbols may no longer form part of a useful vocabulary with which to speak to this age, especially if they embody meanings that are unique to a particular culture.

How does this happen? Much of Christian symbolism in the visual arts takes words to interpret it. This means that the art is dependent upon a filter of intellectual content if its meaning is to be understood. What the art means is limited to a truth that the viewer "gets." Of course, the problem that artists have with this approach is clear: Once the viewer "gets" the meaning, the work is reduced to a mere container for an intellectual idea, and its impact is also reduced to a predictable

emotion. It ceases to have meaning apart from these predictable responses. It becomes a visual cliché.

For artists, a symbol's meaning is less literal, more polyvalent. A symbol can never be fully defined; its deepest meanings are discovered by maker, by viewer and in context. Abstract art, for example, invites a wide range of valid interpretations. Often these meanings coalesce, but sometimes they may even seem contradictory. In the context of Worship, a diversity of interpretations brings richness and fulness. Yet for some congregations, polyvalent symbols are a problem.

In addition, much of Christian symbolism is derived from European culture and cannot be expected to represent the experience or the values of other cultures. If the Christian message is indeed for all people, if it is universal, then the arts in which it is embodied and celebrated must be, too. This hints at its foundation, the meaning of the incarnation, of God becoming one of us. Even though many Americans are of European descent, the experience and culture of contemporary American Christians is very different than that of our European counterparts, and now far removed from its European origins. Fundamental symbols cast in European form may contain interesting historical meaning, but they may not move the hearts of those who live outside of the culture that gave the symbols birth. Art — to be authentic — needs to have this power.

This is not new. Different cultures have always created and understood works of art in different ways. Parallel to the tradition of Western Christian art is the long history of a formal style of painting promoted by the churches in the East: iconography. Subject matter as well as compositional form were prescribed and copied generation to generation. To Westerners, every icon of Christ seems like every other icon of Christ. But to the Easterner, praying with an icon allows access to the saint or to Christ through the window of human eyes gazing on an image composed of material things: board and gesso, gold leaf and egg tempera. No two icons are the same; gazing on each initiates a unique encounter. In the West, perhaps the Roman Catholic tradition of venerating sacred images is similar, but for the most part the Eastern approach to the visual image is far from the Western experience of art.

To some it is downright exotic; in the West, we often close our eyes during prayer!

Art Telling the Story

The use of works of visual art in the West was often for narrative purposes. We have a long tradition from pre-Christian to contemporary times of art that tells stories, enough to take a lifetime to learn all there is to know. The church has long understood religious art as that which has a theme that illustrates a doctrinal truth. In its worst form, this has been illustrative propaganda. This is easily identifiable: With propaganda, we are not free to understand the art in any way except one. Multiple meanings are absent; multiple or complex responses to the work are inappropriate. An example of this is the standard depiction of the Last Supper. DaVinci's masterpiece was an original, and had power. But the endless hackneyed copies done since have robbed the image of its ability to prompt engagement with the mystery that it seeks to represent. Because art continually repeats the misinformation that only men were present at the Passover meal, our imagination concerning the role of women and children in Jesus' table ministry is incorrectly limited.

The need for visual illustration has been met with pictures made by skillful hands, pictures that breathe as art. Contrast, for example, one of DaVinci's madonnas and a Christmas card from the stack sent and received each year. What is the difference? Both formats are narrative; both tell the story. Both are perhaps romantic, depicting an ideal, a vision of mother and child a bit removed from the actual reality of childbirth, nursing and rearing.

But the difference is that one evokes a sense of mystery and the other seems silly. One seems awesome, the other only trite. One speaks of the cosmos, of sacred timelessness. In the DaVinci madonna, the viewer is invited by aesthetic skill to let God interrupt all assumptions. The greeting card offers a predictable and easy answer to life's complexities. It suggests that the viewer is safe, that God will rescue us in life-threatening events, if only we let this tiny babe spread peace through the world of our hearts.

Why does the DaVinci elicit belief, support faith, while the greeting card madonna elicits a yawn and invites boredom? Because life's complexities are not addressed by the promise of rescue. Redemption is more than rescue. The mystery of not knowing, the invitation to wonder are captured and embodied in the stronger work of art. The weaker image all too easily proclaims a clear and certain safety. Of course most of us would choose safety over risking the unknown. But faith calls for us to do otherwise. Art can be an invitation to believe, a challenge to take the narrow path by entering into the communal encounter with God that we call worship.

Another popular use of visual materials is decoration. Done with a spirit of joy and passion, it can add festivity and hospitality to an event. But this is quite different than the art discussed here. That art, while it may delight or enrage us, is created to help us ponder, to engage us, to evoke new depths of experience within our spirit. Decoration allows us to be culturally specific; art transcends cultural assumptions.

ART AS METAPHOR

The advent of modern art has suggested another use for art in worship. The church has not yet begun to embrace abstract art seriously, but perhaps this is the most powerful use of art: Art creates metaphor. Metaphor, as a figure of speech, takes two things normally thought to be separate and yokes them together, identifies them as somehow being continuous. So we all think that we know what love is, and we all know what a rose is. But if a poet says, "Love is a red, red rose" something happens inside of us. Our response is liminal, not rational.

As metaphor, art in the place of worship, at the service of the community, can be used to evoke, to help the soul dance between mood and idea, between experience and prayerful reflection on that experience. Here art can work like stage design, like a ritual mask worn by the architecture. Its meaning lies somewhere between its coded information (the idea behind the thing) and its use in the liturgy (how it is experienced). It engages the imaginative spirit by intriguing the eye and yet not quite dictating exactly what is meant. Metaphoric

use of art is very open-ended. It allows a single work of art to hold different meanings for different people.

This is not some kind of relativism: "Oh, that means whatever I feel that it means. And what you feel that it means is just as okay as what I feel that it means." Instead, it is a recognition that a strong work of art, like an authentic symbol, is polyvalent. It *really does* mean all these things — and more. We'll never exhaust it by analyzing it; we'll never tire of looking at it, touching it, encountering it. It has something valid to say to man and to woman, to young and old, to people of any race or nation. The very presence of such art presumes diversity.

The metaphoric use of art in church signals that someone cares about how things look. Like narrative art, there are often cues that refer to a story or to an idea, like the alpha and omega above. But because the work is often more abstract, it demands more from us than mere recognition or recall. Sometimes it is only about color, and celebrates the very act of, say, marveling at the sky at sunset. Other art is about texture, or shape, or composition, or any of many other formal elements. But then how is liturgical art different than any other modern art?

RENEWED ART FOR RENEWED LITURGY

The answer lies with context, which is discussed more carefully in Chapter 3. Because of the danger of narrative art degenerating into cliché, perhaps it is the formal, enigmatic elements of abstract art that hold open possibilities of embodying, proclaiming and celebrating the good news in the next millennium. When such works are properly installed in church buildings, with relation to the liturgical year and the rites celebrated in the space, they come alive with mystery and spirit. The work enhances the liturgy, and the liturgy vivifies the art.

ART AS DIALOGUE

Artists know God to be the God who creates. We know God within the context of ongoing revelation, the context of ongoing creation, a process that invites the artist and the church to evolve and develop, to change, adapt, discard and invent. Making art is a process of letting

go of expectations and living in relation to materials, living with confusion and an iconoclastic attitude toward assumptions everyone else seems to hold. This stance is a commitment to the non-rational, intuitive, uncontrolled, emotional side of knowing. Such art-making is often marked by embracing the mystery, confusion, struggle, darkness and earthiness from which sprout joy, healing, the *aha!* moments of true discovery and all the creativity of the imagination.

Making a work of art does not happen in isolation — no matter how much solitude the artist needs to finish it. The artist is part of a culture, a member of the human community in a particular time and circumstance. It is in honest telling of our stories to one another, and in listening to the truths of another person's experience that the artist finds refreshing movement toward the ongoing revelation and confrontations necessary for survival and growth.

The truth is never known in isolation, just as it is never known completely within one person's vision. We seem to be made to be in relationship, because truth itself is revealed in the tensions of the interaction of more than one reality. Truth seems powerfully cradled between people, in dialogue, rather than contained within a monologue. (Tradition is one voice that participates in this dialogue, not a dictatorial monologue insisting that it alone is complete.)

The life of the artist, specifically the artist within the Christian community, is a struggle with and against the tradition while seeking to add to it. Additionally, art for worship must give evidence of a rigorous attention to the craft of the work, according to the demands of the larger art world. This is not to say that art for worship must pander to shifting tastes and tendencies in the art world. It is to suggest that the rigorous standards that apply to the art of the academy and museum can rightfully be applied to art for church. Art cannot rest on its content to excuse unrealized, underdeveloped form and execution. A fertile interplay between these two worlds — the art world and the church — can begin to weave a pattern as delicate — and strong — as a spider's silken web, a web that bridges truths, a new pattern that stretches out to link two realms that are often perceived as far, far apart: the secular and the sacred.

ARTISTS IN DIALOGUE WITH THE CHURCH

We can recognize this relational principle at work in the following conversation between artists and the church.

WHAT CAN THE ARTIST OFFER THE CHURCH?

We want to give our church songs not yet sung, images not yet imagined, words not yet forged into poems, dances not yet rehearsed in our muscles and bones and all the other dazzling testimonies to the creative power of God at work here within the creation. We long to bring the warmth and disclosure of art to worship; to bring a joy beyond words to the celebration of the sacraments; to incarnate, to give form from the commonness of matter, the pain and sorrow of the reality of crucifixion; to proclaim a promise of resurrection that evokes hope from the whole being, not merely the intellect.

WHAT TASK CAN THE CHURCH OFFER THE ARTIST?

We are desperate for our young to dream dreams and our old ones to see visions. Society seeks conversion in political options, and then despairs when real change doesn't come from that source. We are numbed and sickened by the riots in our streets. We groan over divisions made in the name of justice. We have tried to find the peace of God in rubrics, order in doing things the right way, but it eludes us. Where is God in all this? We long for the good news that God is among us, but we too quickly disqualify that possibility.

 Our faith seems to find its definition often, too often, not in the revolutionary, upchurning, prophetic and disturbing nature of Jesus, but in our comfortable doctrines and our cherished procedures. Then we leave out those who don't fit. Too often we attract a narrow spectrum of people Sunday after Sunday, and bind this "family" together as the body of Christ, like Lazarus, with winding cloths of words, of words, words and words about the words.

 We need artists to remind us of another way of being human. Beyond the delights you bring us, past the beauty or the grandeur or

the provocation you stir in our spirits, we need your passion! You help us experience that life itself is not something that can be contained by definition, or bound by doctrine, or found in the confines of orders, systems or even logic itself. You give us forms that remind us of the mystery that we want so much to connect with, to petition, to worship and, yes, even to name. You give us forms that remind us that we can only note the presence of that mystery, never possess God with the confining labels of theological query or aesthetic form.

MOST ARTISTS HAVE A SECRET:

We never end up making what we intended to create. Always along the way the art asserts itself. The materials create new tensions, new ways of seeing, new possibilities. The act of working it out uncovers what the artist could not fully have predicted. It is a kind of search and research for the artist, a quest, a clarification of discoveries. And in the end, the result of that adventure is what we share in sensate material forms.

Art making is like that. We leave behind the marks of that conversation with the materials that is evidence of that same Spirit, that Holy one, stirring in the unconfined space of our imagination. We offer to the church, like a golden gift, the joys and struggles that wrestle within us toward a form, a melody, a gesture, a metaphor. We understand that art is the way we can hint of this glory, this mystery of the Source of that very life itself.

The church needs us precisely because our work cannot be explained. We say to the church: "You are invited to come into our work, invited to enter it, to be taken up for a moment, for a passage of time that is your life, for time away from time. You are invited to enter into a relationship. Here you are asked to encounter, to listen, to hear the other. And in the hearing, the pause, the silence, what will come?

You will hear what you cannot hear alone. You will hear your new self, the self you will become, because when we enter a relationship, we are always, always different for having been there.

You will hear yourself, your holy self unfolding in a new response, a new thought, a new idea. You will hear then, in the stillness, in that place where your imagination is invited to meet the art — in that stillness, you will hear!

But what is it really that you will hear? What we invite you to hear cannot be controlled. It cannot be defined. It is not a gentle flow of small breezes from nowhere on a hot steamy day. No. What we unleash is the stuff of a gale, of a hurricane of a mighty wind, of a Pentecost wind. It is the wind of freedom, the breath of revolution, the glimpse of what might yet be. We artists destroy conformity. We demand plurality. And that can be very threatening.

TOO OFTEN THE CHURCH RESPONDS TO ARTISTS:

That is threatening. You scare us. We don't understand what you're about, and besides, there are other things we need to do, like feeding the hungry and sheltering the homeless. So, look, maybe you can just paint us a nice picture of a Bible story, or why don't we just have you do a stewardship brochure and we'll leave it at that.

BUT AS ARTISTS WE SAY:

Let us loose, and the church will never, never, be content with being less than it could be. We will show you visions and encourage you to dream dreams. But each dream you make will demand change, will demand dying to the old and being born anew. What we bring is very, very dangerous.

So is Christ. But wait. Jesus tells us more than that change is in the air. Jesus tells us the name — like Moses before the burning bush — and we hear the name of that revolution. It is love — my love of you with your loyalties, your love of me with my passion, our love together of our creator God, your love of my brokenness as an artist, of my imperfections, my love of your resistance and compassion for the cost of change for you.

THE ARTIST IN THE CHURCH

This is where art must take the church — to a place where we no longer assume what we always assumed, where we no longer desire things that we really do not need. We have an opportunity to see art as a separate reality with which we can have a specific kind of relationship, and that relationship teaches us an openness that is marked by respect and reverence. It is a place to rehearse how we must learn ultimately to treat one another. Art can nourish an aesthetic of compassion.

So it is not enough for the artist to bring the church a new vision. As it is now, few of us, church or artist, can truly see or actively engage new images because we cannot open ourselves to others. Both the artist and the church then need not only to find new visions, but also must practice a new aesthetic, a new way to see. Can you imagine the vitality of a community that really listens, hears, enters relationships with art that open the imagination rather than merely restating old ideas?

Perhaps it would be enough to talk about the gift of the opportunity to learn safely about relationships as a justification for the arts being actively supported by the church. There is an even larger picture, however.

The artist has borne the image of the isolate, the deviant seer in society, who by living on the edge has been able to see most clearly the trends, the shifts, the new paradigms emerging. But there is another vital, rich place for this sensitivity to be nurtured. It is in community.

As a member of a community, the artist becomes not the deviant but the listener, questioning and absorbing diverse answers. We artists note the tensions and unresolved assumptions. We then retreat and respond in much the same way with our brushes, fibers, canvases, stones or whatever materials we use. We carefully listen, and we too hear a new voice, a new call. We search and find a form that can suggest a kind of mediation between what we have heard in the community itself and in the voice of the materials.

Listening like this is a mysterious and powerful process. To be heard is the source of great healing, of love, of life-giving spirit. Is this what we are called to become as artists in the church: conduits of

healing, both for ourselves and for our communities? This is very different from the role of the artist within our society today, a society filled with material production, public consumption, competition for attention and the dizzying spiral toward the financial and social success we are taught to pursue.

From another perspective, one might notice vibrancy and sensuality in the appeal of this art that comes from being in community. As we become willing to open ourselves to otherness, the process of relationship, we open ourselves to a rich liveliness. We experience desire as an energy as we seek to understand, to change, to grow. We feel the throb of the life-force at work as we view art — and relationships — with this degree of expectancy and curiosity. This is a spiritual act at its core.

What does it mean to say yes to the power of being an artist-in-community? It can very risky. It means saying yes to the unknown, to relationships that form us in surprising and uncontrollable ways. It means being willing to be challenged, to be impregnated with the stuff of life. It is being willing to stand in the light of truth and absorb as much as one is able to absorb. It is recognizing that none of us is yet finished becoming who we will be, and that our lifework is to follow this path of becoming who we are called to be until our last breath.

ART AS SACRAMENT

Can we, as artists in the church, take a different stance toward art? In the art world, it is a challenge to turn our back on the modernist, heroic, belligerent ego of the isolate, whose work is often marked with skepticism and a dreary, cheerless, calculated approach to marketing a product. Can we embrace our own deep hunger for the real, for mystery, for freedom, and turn away from the siren of the compulsive consumption in our society?

Can we move toward embracing the paradox of the opposite as a way to relate to the other? Can we listen? Can we hone our ability to respond, and not simply react, or crush, or consume or exploit? Can we teach others an aesthetic of compassion, and find new ways to bring that alive?

To be an artist can be about expanding the human experience with the gift of imagination — to activate not only our own imaginations, but to find ways to invite the community to learn to exercise its own imagination, to honor the gift and its spark of divinity, wonderment and vision.

For the church, the challenge is a prophetic call to use art today in a very different way. Can the church use art as a model for relationship and as a way to create community? Can the church consider the artist in new ways, and liberate the artist from the confines of religious aesthetics, from slick and easy solutions to complex work, and honor the struggle and sheer energy it takes to create anything? Can we the church open ourselves to change, as to a gift, celebrating the blessings of diversity and the growth of flexibility as we face new ways of seeing? If so, the church and the artist will find that art, the work of human hands and hearts, is a sacrament of divine artistry, a sign of the One who not only makes all things, but makes all things new.

2

PRACTICALITIES OF DESIGN

You have given command to build a temple
on your holy mountain,
and an altar in the city of your habitation,
a copy of the holy tent that you prepared from the beginning.
With you is Wisdom, she who knows your works
and was present when you made the world;
she understands what is pleasing in your sight
and what is right according to your commandments.
Send her forth from the holy heavens,
and from the throne of your glory send her,
that she may labor at my side,
and that I may learn what is pleasing to you.

Wisdom 8: 8 - 10

A CASE STUDY

The commission began with a call from Gale Morris, canon at St. Mark's Cathedral in Minneapolis. She asked, "I would like you to work with our church, but I do not know what I want to ask you to do. What are your current interests?"

Quick to spot an opening to get up on my soapbox, I replied, "I am very interested in relationships, and would like to explore some of my ideas in theology and in art." Back and forth our ideas went, and we decided that we would begin with a retreat using art materials to explore relationships.

For ten weeks, the nature of relationships was explored in preaching (liturgy) and in teaching (formation programs). In the second week, participants were each given a strip of sheer cloth, about

1" x 6", and asked to reflect on a particular relationship in their lives and to pray about the relationship during this time. Then with paint or thread, by assembling a collage or by writing on the fabric, or in whatever way they wished, participants were encouraged to use the cloth as an artifact of that prayer.

I returned to the cathedral after nine weeks, and with the congregation, wove these pieces into a huge canopy of the people's prayers that went from the back to the front of the nave. (See plates 38 and 39.) Then the context for the work of art came alive in liturgy. The pastoral team organized a wonderful service of lessons and carols — an old Anglican tradition revisited — that we held under the canopy on Mother's Day. One of the readers was a woman of about 80 who walked with two canes and was so small we could barely see her over the edge of the pulpit. She read:

> My children are coming today. They mean well. But they worry. They think I should have a railing in the hall. A telephone in the kitchen. They want someone to come in when I take a bath. They really don't like my living alone.
>
> Help me to be grateful for their concern. And help them to understand that I have to do what I can as long as I can. They're right when they say there are risks. I might fall. I might leave the stove on. But there is no challenge, no possibility of triumph, no being alive without risk.
>
> When they were young and climbed trees and rode bicycles and went away to camp I was terrified. But I let them go. Because to hold them would have hurt them.
>
> Now our roles are reversed. Help them see. Keep me from being grim and stubborn about it. But don't let them smother me. I have been young and now I am old.[1]

This talk of roles and of risk, of being young once and of growing old, of caring for others and then being cared for by them — this reading and the other texts read and sung at the service were proclaimed beneath a canopy that sheltered all, that connected and covered all in the church and symbolically all the world. What we had fashioned here was the tent set up under the oaks at Mamre, where Abraham and Sarah

dined with divine visitors in the ultimate covenant. Here, too, was the meeting tent of Israel, the place where the people found God in each other, sojourning in the desert as refugees and as pilgrims. This was also the wedding canopy stretched aloft in many cultures over bride and groom, here stretched over the marriage of divinity and humanity. The prayer canopy at St. Mark's Cathedral invited all who experienced it to place their own relationships in a wider context. The design invited participants to see their own relationships as part of a whole.

BASIC ELEMENTS OF DESIGN

The best art for liturgy successfully embodies basic elements of design, of which I name seven. Sometimes a work includes several of these elements. Rarely does a single work employ all seven. The elements are: light and dark; transparency and opacity; color; pattern; texture; scale; movement. Each of these elements is discussed and illustrated by way of a specific project. These are not offered as patterns to copy, but in the hope that the specific examples will stimulate your imagination and your own creativity. This discussion of design and process continues on page 33 after the examples that follow on pages 18 - 31.

Light and Dark

■ One of the most significant visual experiences that we have — perhaps the foundational one — is the perception of light and dark. Through illumination and shadow, the use of both bright and deep colors, one honors both the light and the dark as sources of information. Each needs the other to contribute to wholeness. (Remember not only the pillar of fire, but also the pillar of cloud!) By placing these together in a design, each is activated, and the space between light and dark becomes a place of mystery.

In this example, the congregation entered the church on Easter Sunday into a space that still spoke of Lent. In this particular parish and Christian tradition, there is no celebration of the Triduum, no transition from the forty days of penance and preparation to the fifty days of rejoicing. So there was a need to make that transition on Easter Sunday, and the environment for worship became a strong tool for doing so.

The service began with the singing of "Were you there?" by an unaccompanied solo voice from the dark balcony. The readings for the day were read, and then a hymn was sung by the choir accompanied by trumpet. As this began, the curtain of Lent dropped, revealing that on the other side of the curtain where the crown of thorns sculpture had been for Lent, a crown of victory was in place, with light shining upon it.

After the choir finished, the organ began the introduction to the hymn, "Christ the Lord is Risen Today." Simultaneously, banners of color rose from the floor, each on a structure like a window shade roll. Vestments and paraments were changed ritually — with graceful, deliberate movement. A procession of people bearing baskets of colorful flowers entered as others lit all the candles (similar to what happens during the singing of the Gloria at the Easter Vigil). It took only the 45 seconds of the introduction of the hymn to do all this: All were well-rehearsed. Then all the lights came up, and the people rose and sang in this new space about resurrection.

A word of caution: When unfurling banners and placing flowers is to be done as part of the ritual action, as opposed to being done in the empty church building before the liturgy begins, all

mechanical systems must be in perfect working order and all participants must be well-practiced. Amateurish stagecraft will distract people from entering into the ritual. Some dramatic elements — well prepared and carefully executed — can help the assembly participate more fully. The practical (and technical) task of lighting lamps in the dusk is a good example. It gave rise to the dramatic lucernarium, or service of light, that begins the Easter Vigil and solemn evensong. ■

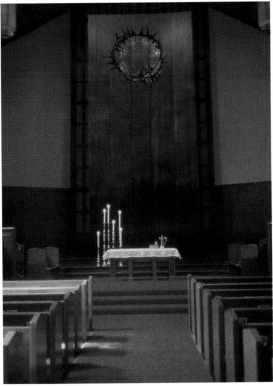

"Lent," paint on fabric, 17' × 40'.

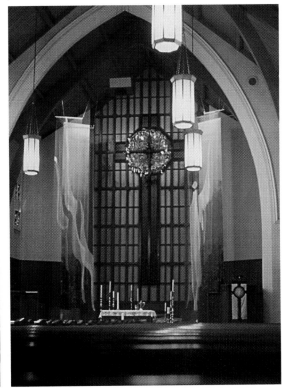

"Easter," paint on fabric, 5' × 25'.

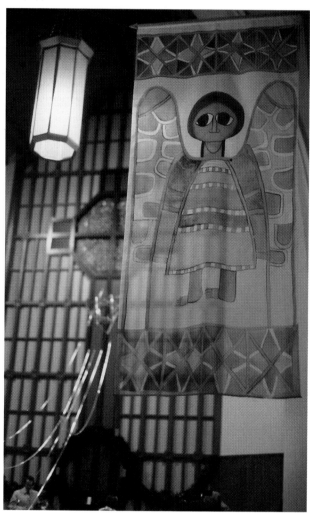

■ Sheer, scrim-like fabric and paper are common media for hangings in the place for worship. They are lightweight and easy to hang. They appear and disappear in the light as they move in their high places with the air currents and with the movements of the people below. The existing environment is always visible through them. The use of transparency in art for the liturgy hints clearly that other realities are present. It allows a multivalent interpretation of the art and, by extension, the liturgy.

Watercolor on nylon, 4' × 12'

In this example, an angel is painted on sheer fabric with watercolor and then stitched with invisible thread (in widely spaced stitches and no turned hem) onto nylon net. In the second example,

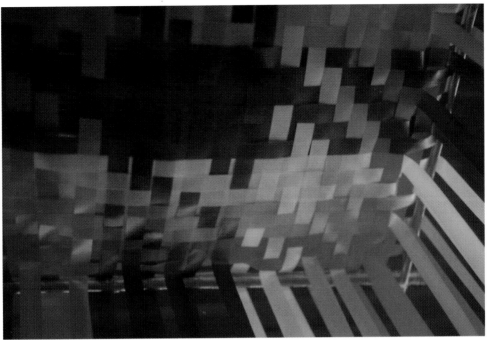

Canopy, 15' × 10', supported on 8' poles.

a wedding canopy transforms the space into a place supportive of the intensity of sacred vows.

Opaque materials also speak on a symbolic level. What does it mean to veil a work of art in the worship space during Lent, for example? What does it mean for the veil to drop, or come off — as in the Lent-to-Easter project described before? Could the use of opaque materials on occasion speak to our need to acknowledge that sometimes our vision is limited, our sight finite? Just as darkness and shadow are corollary to appreciating light, so is opacity corollary to transparency. Perhaps this is best exemplified in vesture for people: Ministers of the liturgy become more transparent when they are clothed in opaque vesture. When a preacher is adorned in a finely woven robe of opaque linen or wool or cotton, for example, grooming and taste in clothing are not as apparent as his or her preaching. Covering and uncovering the material things of the liturgy — furnishings, images, vessels of bread and wine and water and oil — can help us, over time, to see them better. ■

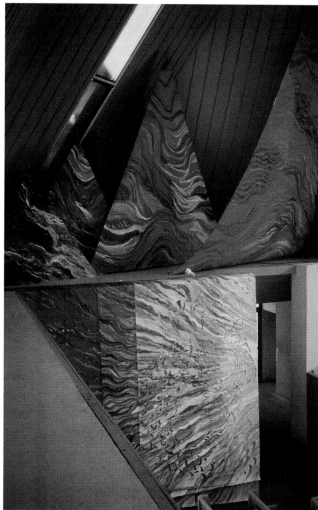

Paint on paper, 6' × 9' to 22' high.

■Our spirits respond to color combinations and harmonies with mood. Color affects us with both personal and culturally-bound associations. A choice as simple as using colors that expand and enhance the particular environment rather than relying on stereotyped images to create meaning helps us to notice that someone has paid attention to this place. So we do, too. The color becomes an invitation to enter a holy space, or a barrier to warn us to be careful.

Some churches pay particular attention to a scheme of liturgical colors. But it is a shame that dependency on catalogs and mass-produced objects has limited some people's appreciation of the colors green, red, purple, black, blue, white, rose and gold. As churches develop their collections of textiles, it is important to determine what shades of green look right in the particular space, given its environment, particularly its light, both natural and artificial. Some churches, for instance, have developed several sets of green textiles to use in the long period of Ordinary Time or Sundays after Pentecost. They have shades of green for winter, for spring, for summer and for autumn.

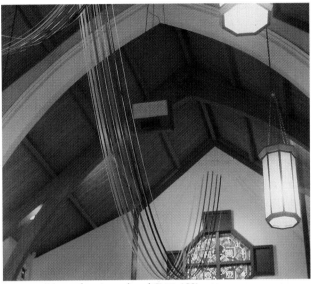

Acetate ribbons forming a band 8' × 120'.

Some Christian communities do not use a scheme of liturgical colors at all, and stress instead a textile collection of ethnic fabrics, combining patterns from various cultures to create a multicultural environment.

In this example, simple florist's ribbon has been hung to create a canopy of a rainbow overhead. The setting is for the Pentecost scripture passage on the coming of the Paraclete, the comforter. With the double meaning of the rainbow, one coming from Genesis and the other from popular culture, and the range of all the colors, this is a comforting image in and of itself. Notice the attention to the detail of the end, as well as the shape of the rainbow itself. ■

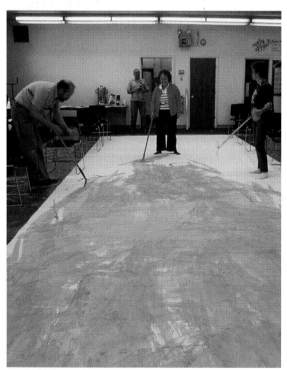

"Behold the Light," work in progress.

■ The use of one element over and over is a very effective visual tool. It does for the eye what the praying of the rosary or another mantra does for the ear, and so it lifts the soul. Pattern reminds us that life is not linear, but made from small steps that lead us into all imaginable forms of dancing. Creating order out of discrete elements yields an experience of power over chaos. It brings us peace and a sense of completion.

For the piece "The Nativity," young people and adults applied tempera and acrylic to paper so that the light in the work all emanates from the abstracted manger. Adults worked under artistic supervision with squeegees to create "Behold the Light," a temporary banner for a choral concert. ■

"Behold the Light," work in progress

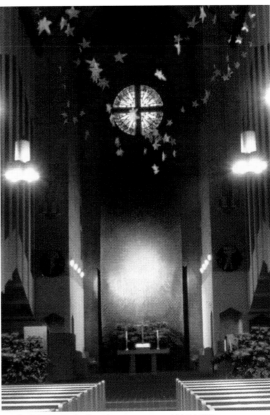

"Behold the Light," paint on paper, 10' × 32'.

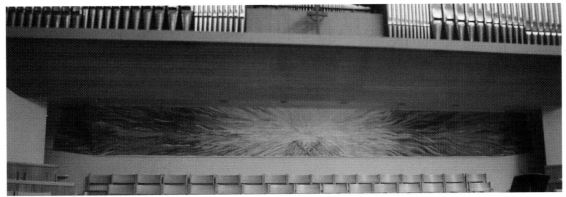

"The Nativity," paint on paper, approximately 31.5' × 5'.

 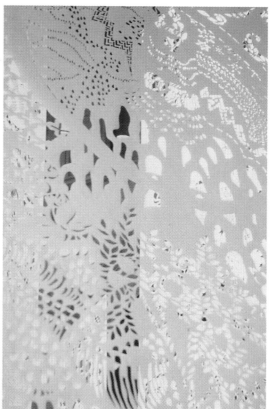

■Shiny, dull, rough, smooth, complex: Texture speaks subtly of diversity. Like other images of contrasts, texture shows that life is varied and variegated, not just smooth, not only rough. Paper lace is made by cutting holes to create a texture and a pattern in paper, a texture and pattern that reveal images by what isn't there as much as what is there. The material itself and the variety of textures create not only the particular image but also a sense of great fragility in the paper lace examples shown here. These are very large and hang free in space rather than against something like a wall. Air currents move them gently, adding life to the work itself. ■

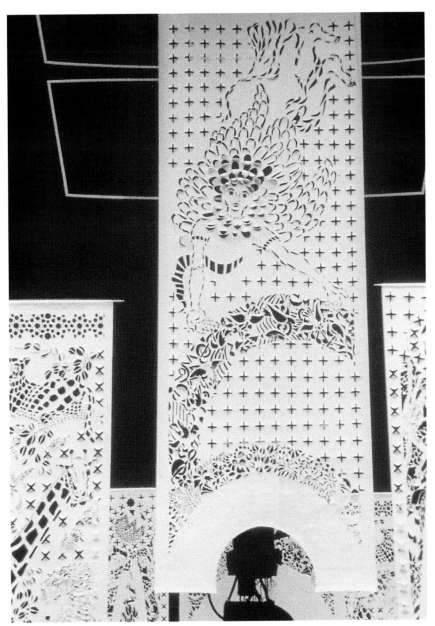

Cut paper, 9' × 25'.

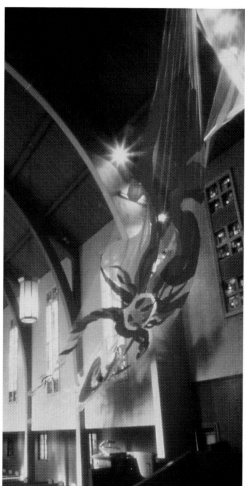

Painted nylon.

■Some work is just too small for the space for which it is intended. It is made for the intimate scale of the home, and doesn't read past the second pew in the church. The architecture of the church is usually our clue for scale. The over-scale, large, soaring space moves our human boundaries to places of imagination and spirit. Here a work done for Advent swoops through the space. The work is polyester basted onto nylon net. The images represent the four elements of earth, fire, air and water. There is no sentimentality here: Advent is also about judgment and the final things, about this world passing away and the new one being born. ■

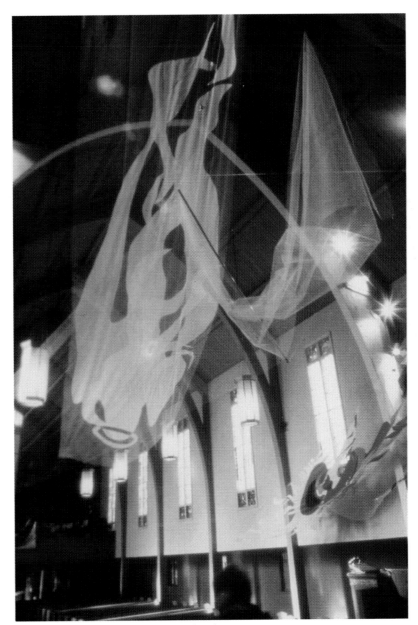

Two of the four angels representing the elements.

■ A work can be changed during an event by the addition or subtraction of pieces, or it can imply movement in the gesture of the lines. This prevents visual art from being static. The example is from Pentecost. It is an explosion of color in the air of the nave of the church, responding to the story of a rush of mighty wind and

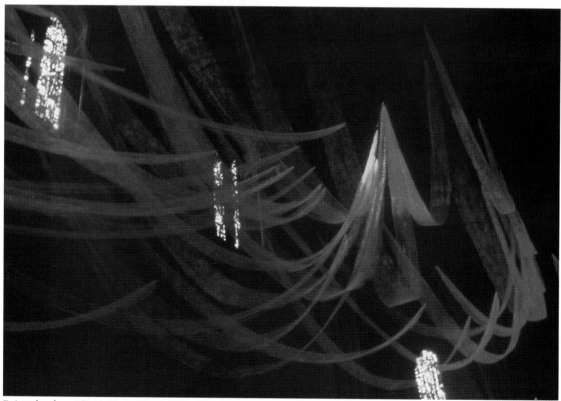

Painted nylon, 18" × 10' to 18" × 120', side view.

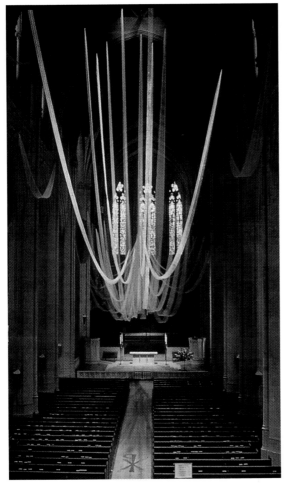

Front view

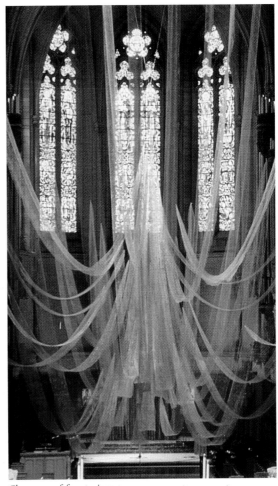

Close-up of front view

tongues of fire in the Acts of the Apostles. The work is composed of fifty painted nylon net strips, individually hung. The work moves, each element gently rocking in air currents, creating a sense of ebb and flow. The movement is almost imperceptible, subtle but significant. The work evokes without being literal. ■

THE ARTIST AS CULTURAL WORKER

It is not enough for the artist in the church to be a good designer. I now call myself a cultural worker, and the focus of my work is visual culture. What do people see? And how do they see it? Time and time again, I see the excitement as a project begins to focus, and all the diverse talents brought to the project by the participants begin to form a constellation. The secret is that this focus is supplied by the presence of the artist among the people.

Art is not, as we are taught by our institutions and our culture, only about making things. It is about using materials to take notice of God at work among us now and here, in this time and place. And when working in temporary media — seasonal environments — we might also expect that what we learn now is not what we will learn the next time that we ask the same questions. The nature of the materials and of the project suggests that we are oriented toward a process — a kind of process theology of the arts! Art becomes not so much an object as an encounter, an event. The resulting product embodies the event. The artist animates and organizes and encourages the participation of all who respond to the invitation to encounter divine mystery through art.

I see another potential for this kind of creative activity: using art as a way to learn how to treat each other. Having learned to listen to and to respect the materials and discover their own intention and integrity, I come to them differently than an artist who uses the materials to execute his or her own vision, imposing his or her own will on the materials. Instead, for me, a dialogue with the materials begins, and the artist's role is to listen and respond not only to his or her own inner voice but to the presence of the materials and the subject. In a mystical way, these three elements — artist, materials, subject — become a community. Creating art is a way of practicing interaction in the world. The balances that we learn through making art in this way are reflected in our human and ecological relationships.

We also learn about risk-taking. Art is never filled with spirit unless the artist is committed, to the point of taking risks. This is true of friendships also. If I hold back in fear, if I fail to see truly because of inattention, a relationship suffers. It is the same with art.

How can artists in the church be more attentive? How can we be more willing to take the necessary risks? Discerning and developing a good process helps. And attending to the basic elements of design is a necessary first step in this process.

A Process for Design

My process of working out design is a method distilled over years of work with various churches.

I prefer to begin with a Biblical text or a carefully crafted statement about the season, feast or event. Beginning with the anchor of these words, I listen to the planning group as they define for me what this reading might mean. Often I ask questions to clarify, or add my own voice to the mix. If the meaning of the text or season is not apparent after some discussion, I ask people to clarify how it might work its way out with examples from their own lives. Simultaneously I doodle. I simply let my pencil wander.

This doodling is a way for me to process the work on the right side of my brain and escape the limits of the very words I am attempting to clarify. This is where I think associatively, responsively, sensuously. Over the years, I have observed that the places I get ideas for visual design are in a corner of the side of my head and in my solar plexus. I pay attention to these places, breathing into them deliberately during the design meeting and my doodling. Your own internal places for creativity will be different. I found mine by paying attention to my body during such planning.

Sometimes the ideas come to me directly during these planning sessions. More often, I must fish for them. There is a delightful story I once heard about the artist Ben Shahn. A reporter had come to interview him about his creative process. When Mrs. Shahn ushered the reporter into her husband's studio, announcing that he was hard at work, the reporter was distressed to find Shahn lying on a couch with his eyes closed, his cane resting across his torso. The reporter sat in a chair, watching for a while, growing more and more impatient. Finally Shahn stirred.

His cane rose suddenly, its hook sweeping through the air. "Aha! There's one!" he exclaimed, meaning an idea. Then the cane came down and the artist fell silent. The reporter rose, demanding an explanation. "Hush," came the answer. "Can't you see I'm hard at work?" After a few more minutes of watching the artist lying in silence, with closed eyes and cane poised to rise again, the reporter could stand it no longer and left.

My process is a little more active. I go about my day, always with about 20% of my attention on the design question. It is constantly there in the corner, rising like bread dough. I must be alert and pay attention, because suddenly, an idea breaks in. It could be something that I see in a movie, or as I walk along the street. It could rise in a conversation, or from my reading. It might even be in a dream. I never know where it is coming from, and I remain very alert for this focus.

Many ideas come during this process. Some I write down. Some I sketch. Most I just notice. But all of a sudden, one will come to me and I experience a long, centered, strong spine of clarity in my body: I know that I have found a direction to explore. I never know what a design will look like in the end. This direction is only a clarification of how to begin and what materials to use. I never begin a project without being centered like this. This process can take up to a month to ferment and I cannot rush it. I have learned never to promise to meet short deadlines when people ask, "Next Sunday could you . . . ?"

Once I understand how to proceed, I take this information in words or sketches back to the planners and I ask, "Is this what you want the work to accomplish?" and I make sure I understand what they intend. Then I reveal the design direction and ask, "Does this seem to do what you are intending?" Usually they have some modifications or ideas I have not thought of, and we explore how we might integrate these with what I have proposed. When we reach consensus, I begin to make the art.

Along the way, the design usually expands and becomes richer. It is appropriate here to discuss something we artists are taught in art school that I no longer believe. We are taught to create our own individual work. We are taught that what is valuable and honest is

something we have made *all by ourselves.* We are seldom exposed to art done collaboratively.

Most of my work could not be done by one person. It is simply too large. I hire assistants; I work with volunteers, especially parishioners. I am responsible for the overall design integrity — that is my work — and components that contribute to that design. But the people who work with me come up with ideas also. Holding the vision of that larger integrity in mind, I find ways to include their ideas too. These ideas excite me and people get a lot of joy seeing their ideas incorporated. What ends up happening is that we have a very good time together and we make the art.

Good design for the liturgy does not merely depict texts, though. It is not merely visual illustration. For example, if the text talks about five fishes and two loaves of bread, it is not our task as artists simply to depict this. It is our task to reach beyond literalism, behind an easy answer, to find the miracle in the story. Here our power could be to evoke awe about the level of sharing that must have happened to make this miracle a reality. Our work is not so much to make the Holy visible as it is to proclaim that the Holy is present.

3

MAKING GREAT ART FOR WORSHIP

She seeks wool and flax,
and works with willing hands.
She is like the ships of the merchant,
she brings her food from far away.
She rises while it is still night
and provides food for her household
and tasks for her servant girls.
She considers a field and buys it;
with the fruit of her hand she plants a vineyard.
She girds herself with strength
and makes her arms strong.
She perceives that her merchandise is profitable.
Her lamp does not go out at night.
She puts her hands to the distaff
and her hands hold the spindle.

Proverbs 31:13 – 19

CASE STUDIES

What are the strengths and weaknesses of each of these design ideas?

1. The gospel reading is the Sermon on the Mount. Banners are prepared with the words "Poor in Spirit," "Merciful," "Peacemakers" and others from the text, perhaps made in different colors to point out their diversity of meanings. They might even be on poles and raised up or processed in during the reading. Perhaps they are further designed as pieces of a puzzle, forming a cross when finally put in place.

2. Psalm 23 is sung. During the verses, slides are projected of sheep grazing in fields. A sheepskin placed on the floor in front of the baptismal font completes the installation.

3. In the first reading, Joshua calls the people together for a covenant choice. We read in Joshua 24:15, "Choose this day whom you will serve!" In the air over the altar two long thick ropes are suspended, one black and one white. The white one descends toward the front of the altar and ends near a lovely flower arrangement. The black one ends in a pile of old cans, scraps of lumber, wires and other refuse.

4. Advent is coming. You and your committee make elaborate plans for an Advent wreath, for greens all around the church, wreaths in each window. And in the fourth week, so that you can enjoy them for a while, poinsettias are arranged in racks near the pulpit before being brought to shut-ins in the week after Christmas.

5. The sanctuary looks bare. Placing flags on either side of the altar brings in some color, and it means so much to the older members of the congregation who fought in foreign wars. The flags were actually given as a memorial, but have been there so long no one can remember the family that donated them.

Why are all these plans doomed to failure? What is too small about the design solution in each case? Think about these questions as you read on. At the end of this chapter, we'll return to these designs.

Making art of all sorts takes a lot of time. Because the purpose of our art is to inspire worship, it's important that it convey meaning to the viewer who has come to worship in this place. How does someone perceive this work of art as part of the liturgy? Do we need words to make the work connect with the texts or actions? Can using words take away from the work? What makes both the work of art and the actions of the liturgy stronger in each other's presence? What is limiting about simply stating themes in a narrative form? Three elements — form, content and context — need to be considered.

FORM AND CONTENT

The meaning of a work of art lies on a continuum between *form* and *content.* Some art today is purely about form. Its meaning is completely dependent on a formal element, such as the wonderful matte color of blue flock on a huge bell shape in my local museum of modern art. This kind of art presents meaning within an aesthetic excess, that is, its "message" is its form, color and texture. What the materials are, and how they are presented, contain most of the meaning of the art itself. We see this in nature as we gaze contemplatively upon a spectacular sunset, an analogy to this aesthetic formalism.

At the opposite end of this continuum, rational content carries the purpose of the art forth. The style presents the message in an attractive and accessible way, so we stop and think about its meaning, finding it within the tradition pictured or our memory of that tradition. Most religious art fits at this end of the continuum, because most people think that the purpose of religious art is to teach us something about the faith. Usually, though not always, such work depends on its pictorial content to carry the purpose of the art forth. It is judged worthy if it either communicates the story or illustrates the morals accepted within its community.

Sometimes this intended content is verbal or symbolic, not pictorial. One might even find that its meaning is coded in symbols traditionally understood within a particular culture. This is why we often see butterflies at Easter, or helium-filled balloons released at Pentecost: attempts to use pop-cultural images to embody faith's mysteries. But these popular cultural items too easily become visual props, and we avoid searching for more interesting, fresh or lasting symbols to embody theological ideas in works of art.

Sometimes, art for worship is presented with prevailing taste as the aesthetic measure. A home-magazine look, safe for any interior designer, becomes the standard of appropriateness. Such art is often plagued by romanticism, and is "safe" — causing no controversy — according to accepted norms of pop cultural aesthetics. We find little difference between the aesthetics of this sort of art and of advertising. Indeed, it often is commercially designed and sold within the market

system through catalogs. It lacks the edge and verve of the gospel; it's "nice" and "pretty" instead. Settling for art like this is costly. Instead of giving us practice with challenge, it sedates us with comfort. What is the cost of this comfort? Ease, numbness, irrelevance are the content more clearly communicated than anything of salvation.

Great art for worship lies somewhere between these extremes on the continuum of form and content. It has an edge to it, which means often that it is more enigmatic than predictable. It functions more as metaphor than as literal truth. It can make us uncomfortable with its multiple meanings, especially if we are in a community that values a uniform or predictable theology. Its main purpose is not to decorate or please. Its appropriateness for worship is in the fact that its meaning cannot be contained in either form or content, but shimmers between both. Often it participates in creating its own meaning, rather than telling us about something. And its primary function is to serve the liturgy, to make it come alive in a new way.

The materials used are often very simple, and — like the material elements of the eucharist itself — are often familiar parts of our cultural experiences. Just as in the eucharist, bread and wine are transformed into something else, so with the making of art we engage in a similar act of transformation. What was once mundane becomes an agent of meaning through the intention and action of making art. What once was merely paper, paint, fabric or other raw material becomes something new, something born anew. The hand of the artist is evident. We sense stitches, or brush strokes, or edges or any of the other qualities of the hand at work, and that communicates passion, vigor, caring.

Art also can be proclamation, but with a different form of communication than words. This proclamation appeals to another place in the human soul, that of intuition, of dreams, of non-rational thinking and of persuasion. When words seem necessary, they can be used as a title for the work, rather than in writing all over the work itself, like a billboard. Often such work is abstract, with its content embodied by the use of materials and the principles of light/dark, opacity/transparency, color, repetition, texture, scale and movement discussed more fully in chapter two.

This leaves us with the practical question: How does one design such works of art that proclaim holistically, to the intuition as well as to the intellect? To begin to answer this question, we must explore another way the viewer discovers meaning.

CONTEXT

The other element that gives a work of art meaning is its context. This is especially true of art for use in worship. The first requirement for designing powerful works of art for use in worship is that their themes must be clearly stated in a form that reflects the concerns of both the theologian and the artist. But this can be difficult to do well, remembering that art deals more in metaphor than in literalisms. While any act of liturgy has many themes, the liturgy can never be properly understood as a mere vehicle for the teaching of ideas.

Often, for the theologian, the themes of the liturgy and of the season of the liturgical year can be encapsulated in dogmas or statements. Here are some examples: "Christ died for your sins;" "God is understood by the Christian as a Trinity," "Exodus is an event that coalesces the people of Israel."

Artists more often perceive those themes in the liturgy that have an emotional or affective content. We need to make the art from an emotionally responsive — not merely didactic — center. And we need to find the theme's meaning within our lives today — our lives as individuals, but more so our lives as communities. We need to understand what that theological theme means as the word of God to our particular community at this unique time in history. And so we are more interested in responses than in facts.

So the artist may find resonances like this in the theologian's statements:

Christ died for your sins. I know guilt and shame about my failings. I find comfort and hope that God will not hold me personally accountable for these failings. The joy of this trust transforms not only me, but this community of which I am a part.

Or this: I know that I fall short of the glory that I am made to be. But I also know that my failures are the doorways to my growth

and understanding. These are the two sides of the same passageway: awareness and freedom. I rejoice in how wonderfully God has made me, that this is my true path.

God is understood by the Christian as Trinity. Just as I am more than who I am at this moment, so it is with God. I am my past, my present, my future. I am who I am because of the relationships that I have with others. God is understood to be in relationship: the Other, outside myself; my brother Jesus; and the spark of Spirit awakening in all of us all the time.

Or this: God is too big for a simple definition. God is all around me, within me and between me and all I encounter. God is everywhere I look, amazing me, delighting me, teaching me, encouraging me, disciplining me and loving me — all at once. Sometimes I sense one aspect of this more than others, but it is all the same God. This is both mysterious and very simple.

Exodus is an event that coalesces the people of Israel. Within the story of our faith, one of the most compelling events is when Moses, Miriam and Aaron led the people of Israel toward the promised land. We know within our own lives that we are also being called toward our homecoming, and it is the journey toward that home that makes us a people.

Or this: As I live out my life, I sense times of conversion, of liberation from former patterns, former relationships, former comforts. I am called out, and the passage is often difficult. It is a wilderness. But I also have hope for the various paths that the journey might take, and trust that I will find new life and new challenges ahead.

LOOK FOR CONNECTIONS

As I design, I am always looking for the emotional connections, the aches, hopes, desires and thrills within the story. I am also looking for the unspoken elements, the story beyond the words. If I do not hear these unspoken elements, I mention this absence to the parishioners with whom I am working, or ask questions to clarify this connection. Sometimes such questions are the greatest contribution of the artist, for we remind our community that words alone, even the finest words,

cannot completely touch our hearts and souls. Hearts and souls come bound together with a story, a vision, a dream, a memory. When we can unite mind and heart, we can form an incarnational truth, God among us, that is life-saving. Why make art for any other reason?

Once the idea is clearly and specifically spoken, once the emotions and applications to contemporary life have been articulated and agreed upon as clearly as possible, the work of art can be developed in all the richness of the forms possible in liturgy. But first there is a commitment from all parties that the discerned theme is the content. When the parts all work together to proclaim this theme or aspect of the liturgy, there is little that can match the power and fullness that that work of art brings forth. Homily, readings, music, hymns and prayers bring fullness to each other when integrated. The same is true for works of visual art.

In such planning, the materials may be the clear carriers of meaning within themselves (an emphasis on *form*), and the content of the verbal and the material have concentric meanings. Or the art may consist of transformed objects that find deeper meaning within the larger context of the action of the ritual itself.

CRITIQUES

What about those design ideas presented at the beginning of this chapter? Here are my critiques. Yours are just as valid and important.

1. This plan holds some good intentions: The use of different colors is entertaining. But what does it accomplish to wave around the words that are spoken? How is this different from propaganda? While no one would be offended by this art, it would neither stir anyone with any degree of passion. Completing the work with a cruciform joining of puzzle pieces is trite and predictable, and does not amplify the text visually. What other shortcomings do you detect?

2. Most of us have little experience of sheep. Adding pictures of a touch of nature that is already unfamiliar may push the gospel even further away from the typical urban congregation. It probably will not bring the gospel into our own situation, unless we keep sheep as our

livelihood. The use of the pictures is manipulative. They stir up a rural romanticism about the shepherd providing comfort, the necessities for life and safety for the animal. I have lately wondered about what eventually happens to those sheep as I prepare my favorite meat, lamb, as a treat. The sheepskin would also be a reminder that for the sheep all is not always so happy. But perhaps it also is too literal. What other shortcomings do you detect?

3. This solution has some interesting ideas. Two paths are dramatically presented, with good didactic presentation. Each one leads us toward an outcome, one desirable, the other not. Once we get it, though, there is not much more to wonder about, so the work becomes too thin. We get the content too obviously, so we close it off and move on. It is no longer an object that holds our contemplative and curious gaze, unless this design has meanings that we did not intend. Colors are read culturally by many: This is also a visual comment on race, implying that white is good and salvific and black is bad and sinful. This lie perpetuates racial division. What other shortcomings do you detect?

4. This solution draws its theme from shopping malls and Christmas hype, while throwing in a devotional aid (the wreath) as a token of the season. Advent is a period of waiting. It originally was a kind of winter Lent, a time of penance and preparation for celebrating baptism at Epiphany. It is also a time of watching and anticipating the surprise of the unexpected nature of God among us. Making the church look like the culture around us is avoiding this time of waiting and confusing the culture with the expression of the truth of the season. The liturgical time to celebrate Christmas, with all the Christmas traditions, including carols, is the Christmas *season,* from Christmas Day to Epiphany (in some traditions) or to the Feast of the Baptism of the Lord (in other traditions). Unfortunately, it is easy to lose the spirit of this time in flat, cliché-ridden liturgies.

Poinsettias are another commercial element of Christmas. If it is desirable to give plants to the homebound, perhaps a more easily cared-for plant would be more appropriate. The gift of a plant might even be questioned anew, and something else chosen. What other shortcomings do you detect?

5. The custom of placing flags in the church seems to have originated in questions concerning patriotism during the First World War. At that time, churches serving parishioners of German background were targets for hate crimes, and as a way to show loyalty to their new country, churches of German heritage placed American flags in the sanctuary. The practice was quickly adopted as a symbolic visual focus for prayer for loved ones away at the front, and as a way to pray for what was perceived as "the right side," the side that God would bless with victory. At the same time, an enterprising flag maker saw a market and created the so-called Christian flag. While this has never been widely adopted, it is sometimes placed in the sanctuary with the American flag.

Roman Catholics then began to use the papal flag. The use of American flags in Roman Catholic churches was in response to nativist questions about whether Catholics could be "good Americans" since they had a "foreign" pope.

We see flags used in European traditions, particularly with regimental flags in churches or even captured flags hung in thanksgiving for the defeat of the enemy.

Our nation prides itself on separation of church and state. The flag is a potent symbol. Placing it in the front of our churches undermines our ability to hear the gospel when it critiques our national policies, practices or history. In addition, not everyone who is welcomed at worship is necessarily a citizen of our own country. We might communicate exclusivity and a lack of hospitality with this image. If color, form and texture are needed to evoke memory and identity, we should use our creativity as artists to address these needs more appropriately for the place of worship, the one place on earth where all people are welcome and one. What other shortcomings do you detect?

ALONE OR WITH OTHERS?

Design and the evaluation of works of art can be worked out by an artist alone, but these are best discerned by a community of people working together. You may wish to follow the guidelines in the next chapter to get started.

4

FORMING AN ARTS COMMITTEE

*Moses then called Bezalel and Oholiab and every skillful
one to whom the LORD had given skill, everyone whose heart
was stirred to come to do the work; and they received from
Moses all the freewill offerings that the Israelites had brought
for doing the work on the sanctuary.*

Exodus 36:2 - 3

SOME GUIDELINES FOR STRUCTURE

Did your involvement in art and the environment for worship come about like this?

The pastor expressed a desire to liven up the sanctuary, and asked for some new banners. Or perhaps there was a memorial gift for the commissioning of new windows. How do you do this?

Or did it happen like this? Several of you began to wonder why the visual arts were a neglected element of worship. You met and decided to think about ways to begin including the visual arts in worship. How might you begin?

Or was it like this? The public school system faced yet another budget crisis, and they let the only art teacher in the district go, leaving art to be taught only by confident classroom teachers, for fun. You are concerned about the children and their development, and want to find a way to create an after-school arts program. You see this as a youth ministry, and ministry to the community. But how can this be done?

Or perhaps you came from a community where art was a vital part of church life, in worship and in education. Maybe your parish even had a lending library of paintings and prints that members could

borrow or rent. You miss it, and would like to begin to encourage art in homes of this congregation. Yet the task is daunting. How to begin?

Or did it start like this? You are an artist and you would like to help others in your congregation explore their spirituality through the use of art materials. Perhaps you yearn for companionship and clarification of what the arts might mean to your congregation. You also want to meet some other Christian artists to share your work with one another. Perhaps someone has suggested an art show, or a festival. You approach parish leaders, who encourage you to begin. Yet you wisely wish to seek the counsel and support of others.

There are as many stories as there are artists. How did you come to be concerned about the visual arts and liturgy? How might you band together with others who share similar concerns? Here follow some ideas for convening, for beginning the work of forming a liturgical arts committee.

BEFORE CALLING THE FIRST MEETING

Meet with parish leaders and share your ideas about what you want to accomplish. Ask for their responses and ideas, and how they think this might work in your church. Ask for names of people who would be of help in beginning to develop this work: There may be more talent in the community than you know of personally.

Approach these people, asking for their help with the specific task of shaping the guidelines for the arts program in your church. Be clear that this is a task of limited commitment, that you are only asking them to help shape a structure. You are not asking them to commit themselves to running a program for life.

THE FIRST MEETING

Have a visual focus in the meeting space. Take time to create a centerpiece, to set a table or place a still life in the space. Prepare a short period of prayer with scripture for your group. One helpful structure that I use is for the group to sing or read a psalm together, and then discuss the question, "How does this connect with your life and concerns about art?" Or, "What comes up from your experience around

these scriptures as we begin this work together?" After all have spoken, keep a minute or two of silence. Do not rush this time of silence; often wisdom comes to us in this quiet. Then ask, "For whom or what shall we pray?" Close this introductory moment with a prayer, perhaps one that all can sing or say together.

At this time, seek to identify the focus of your work together. One way I like to do this is with a game of categories. For instance, if you are interested in visual arts for the place of worship (rather than, say, organizing art classes for the children of the parish), play together by thinking of categories such as textiles, vessels, images, architectural themes in your church building and so on. Working in twos or threes, make a list in each category of things that are needed or possible, or things that you would like to do. Share your lists. You will generate a very long list of ideas this way, and that will help you understand the scope of your work. You may want to prioritize these ideas at this point.

Conclude this process with a clear statement about what it is you want to accomplish. Which spaces do we want to address? The church interior? The church buildings or grounds? Or perhaps you have decided to provide educational programs. Keep it small and simple at this stage. If your project is about art and children, instead of organizing a whole school for children and the arts, schedule a 4 – 8 week pilot program for a "school," perhaps like summer vacation Bible school, or a semester of religious education. Instead of having a national juried show on spirituality and the arts, have a local or town show of artists in the church, and include a time for them to meet and share a meal.

ACCOMPLISHING A PROJECT

Once you have settled on the project, organize the work into a schedule of tasks. Imagine who might be best suited to do this work, and how to recruit them to do it. If some people in the advisory group decide that they want to do a task, encourage them to think about who might do it with them. The more people you can involve, the greater the base of support you generate. Determine a calendar and timeline, and, if necessary, a budget. Appoint an administrator for the project.

Then ask the advisory group to articulate what your project will mean to the community. (You will use this later, in the evaluation.) Once this has been accomplished, you can conclude this portion of the work. Make sure to thank the people of the advisory group for their time and guidance in a public way.

DOING AND EVALUATING

The project administrator coordinates the recruitment, scheduling and execution of the project, delegating as appropriate. Then after the project has been completed, ask a group of those who worked on the project and a group of people who attended, if applicable, to meet with you to evaluate it. Revisit the hopes that were articulated when the advisory committee first met to plan the project about what it would mean to the community. You might ask at this time if it seems appropriate to continue, and if necessary, begin the cycle again with their guidance.

SOME GENERAL RULES

1. Always begin and end everything at the announced time. Respecting people's time is critical. The work is difficult, and to keep people from feeling overwhelmed, it is important to recognize and respect boundaries.

2. Include time for prayer and scripture studies.

3. Thank people publicly for their contributions no matter how large or small.

4. Keep the congregation informed. Written material is usually the most practical and accessible way to inform the larger community.

5. Keep the projects targeted, simple and focused on a particular event or task. Do not assume that once a committee has been established, a whole program is in place.

6. Always keep a written and visual record of the project. If possible, that record could be a bulletin board, a slide show, a scrapbook or other form that others can refer to.

Liturgical Arts Committee

If your group is working on art specifically for the liturgy, the following questions should be clearly understood and answered by your advisory group before you begin.

1. What kind of art work is appropriate for your church to use in worship? (A discussion of chapters 2 and 3 of this book might guide your conversation.)

2. Who decides if the art work fits the church's criteria for use in worship? The parish staff? The artists? The committee? The complainers? The maintenance people?

3. What is the relationship of this committee to other committees (liturgy committee, worship commission, building committee, renovation committee, parish council, pastoral staff, parish trustees and so on)? What is the chain of accountability? Where does the money come from?

4. What is the relationship between the church and the artist(s)? Who decides fees, budgets, ownership, contracts? Who is responsible for the support work for the artist (such as materials, storage, installation, scheduling of use of space, housing, communications)?

5. Is this work to be permanent or temporary (for a feast or season)? (See chapter 6.)

6. What changes to the physical structure of the church might be necessary? For instance, does lighting need to be added or focused? How will the work be hung? Who knows how to do this?

7. What relationships might we want with other churches in the area? Do we invite other churches to participate in the making of the work, or as guests or viewers? How can we share what we have done with others?

8. How is the congregation to be informed about the work?

DIRECTIONS

Here are some directions about art for the place of worship that the liturgical arts committee need to discuss and understand thoroughly:

1. Always be courteous and notify people ahead of time that there will be something new in the space. It is rude to surprise people with strong visual elements when they are not ready for them. You may also remind them that it is only there for a short while in the case of seasonal installations, and that eventually things will be back to normal again.

2. Do not presume that everyone can interpret the art. Some of us by nature do not learn that way. In addition, we are not taught in our schools or our churches to do this. Include some words, perhaps a paragraph of interpretive questions or a committee statement about the intent of the work, in a bulletin or a flyer. But remember that good work naturally evades clear, complete definition. Ask questions to get people thinking. Here is an example:

> The art in the sanctuary today was inspired by the arts committee's interpretation of the sense of awe with which we hear Jesus teaching about the end of the world. In the color, the scale, the image itself, do you sense that awe? What else do you see? What does this mean to you? Speak to someone about your ideas, and hear theirs. You might also find ways to pray about these ideas during the week.

3. Thanking every person who does anything for the art, both in public and in personal letters, creates a sense that it belongs to many of us, has been created by many hands and many sorts of talents.

4. Finally, make it a practice to treat each other with kindness, encouraging and supporting one another in this important work. Making art is difficult. It is costly. It takes time, skill, discipline and above all, connections with the imaginative and creative parts of our souls. It requires a personal commitment. But this is how artists can bring focus, depth, and challenge to worship. It is also where artists can find a home for their gifts.

A Case Study

In chapter two, we discussed how to begin designing by forming a concept of the work in dialogue with theology. Here, it will be useful to give examples of design as visual skill.

This is the process I used to sketch before creating the design. It begins with observation notes taken in the place of worship.

During the preliminary planning meeting, sketches were developed. They were put together in a presentation drawing for the committee. The committee offered the following comments:

Can't we use the whole space above the blank walls also?

I imagine something swooping in the space.

I like the color.

What will we do with our hanging of the greens?

It doesn't look like Christmas.

I want it to anticipate and build toward something we cannot see during Advent.

I want to have a sense that whatever happens, it will involve all of us at the end.

My work at this point was to call the group back toward the content, as they became quite excited about the forms themselves and how they might fill the space below. They also became absorbed in the mechanics of how to hang it in the air. A slanted floor and a 55' ceiling made the use of ladders impossible. After consulting with several companies who proposed to hang hooks from the girders with drop lines — for a lot of money — they settled for a low-tech system of throwing a tennis ball with a line attached over the girders and placing drop lines throughout the church.

A church member coordinated the scheduling of the workers, who arrived to accomplish phases of the work, directed by the artist, from cutting the paper to painting to installation, week by week. See plates 6, 7 and the photo on page 22.

5

PAPER LACE

*All those with skill among the workers made
the tabernacle with ten curtains; they were made of fine,
twisted linen, and blue, purple and crimson yarns,
with cherubim skillfully worked into them.*

Exodus 36:8 - 9

A MULTICULTURAL ART FORM

Paper lace is a term used to describe large sheets of paper that have been designed and cut to create lace-like images with pattern and shapes embedded within the structure. They are designed to be hung independent of a background, in free space, either in front of a light source, as a screen or as a canopy.

I was inspired to create in this medium by a local church for a commission to produce a work for Advent. The church's request was for something narrative to go with the texts, emphasizing light. While musing on the theme and how to suitably develop it, I noticed beside my chair a lampshade with a design of perforated holes and saw how the light through the holes created an image. Later, I found out that papercutting is an art form in Asia, Europe, the Middle East and in both North and South America. From each culture I found answers and ideas. I used these to invent large curtains to hang over the windows at the church. Members of the congregation helped me cut and install them.

The liturgical and spiritual fit of the medium is significant. Paper lace looks very fragile. Because we know it is made of paper, there is a sense that the work must be cared for, and that the experience of it is temporary. The work transmits light, both through the

holes and through the luminosity of the paper when it is hung in front of a light source. Like hope, the image is often made up of what is not visible. Larger work hung in space also has the property of moving in the air currents, adding another dimension: Light and breath are easily recognized as symbols of the Spirit.

MATERIALS

Incidentally, "lace" may be an inadequate word to describe the work, as it varies in height from 2' to 36'. The width is dependent on the availability of suitable paper. Materials and tools are simple. The paper of choice is photographer's backdrop paper, because of its size, relatively low cost, light weight and, because of the short fibers of the paper, the texture that results when it is cut. It comes in 9' x 36' rolls in a wide variety of colors. It can be purchased at photographic supply stores.

This is not a permanent paper and will fade, curl and yellow over time, becoming too aged to use after a few years. Then the work becomes a pattern for a new work. It is easy to cut two copies at once, or even three if you are careful. I clamp the pattern and the new paper together to prevent slipping as it is rolled.

A flame-retardant version of the paper can be purchased for use in auditoriums, theaters or other places that require it. However, the chemicals used create weak spots in the paper and also make it deteriorate quickly.

The paper has a natural curl. There is no way that the paper will hang flat in dry climates. I work with that feature to create texture in the cuts themselves. Flaps are folded, curves are

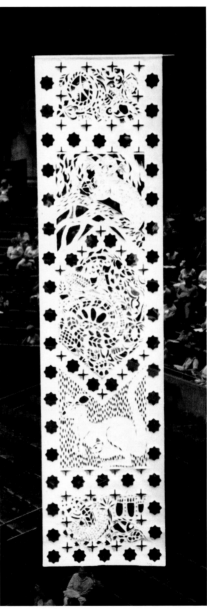

Cut paper, 4½' × 18'.

designed to curl and edges are cut with that curl in mind. In humid climates, the opposite happens, particularly with flame-retardant paper. The paper absorbs moisture from the air, and the design becomes puffy. Repeated patterns, particularly in background shapes, look like quilting. In humid climates, the work will also hang much flatter.

TECHNIQUES FOR CUTTING

I prefer using a snap-off blade of substantial size, so that the arm and shoulder are used in the cutting motion, not just the fingers, as with X-acto blades. Olfa knives (the ones with the yellow handle) fit my hand well. I cut on a self-healing mat of 48" x 72" that has a grid. This type of mat can be purchased in sewing supply stores. Quilt pieces are cut on this. Before I discovered this type of mat, I preferred cutting on posterboard or low-pile carpet. Newspapers or matboard will do in a pinch, but they wear out quickly. Corrugated cardboard doesn't work because the ridges in the material make the knife hard to control. Stop frequently and rest during the cutting to prevent injury.

DESIGN

Creating the work is a matter of good design that integrates positive and negative space and incorporates a vertical structural integrity, so that the work does not sag. That means that small "bridges" are planned within the design to span all horizontal forms. I also plan a border that has no cuts within it at least 1" wide on each side. The work is hung from a horizontal pocket at the top. I prefer to staple this edge to make the pocket, rather than using tape. I like to create interesting borders at the bottom of the work, taking advantage of the natural curl of the paper. You might consider hanging the work like a canopy, with a pocket at each end, or my favorite way, in free space, hanging like a curtain. Well-designed work requires no additional materials to maintain its structure.

Most designs that fail do so because the relationship between the background (negative space) and the foreground (subject matter) is inconsistently developed. It is important to consider both. Our tendency is to concentrate only on the subject matter, as if that is enough

to carry the image. Beware! It is not! Well-designed negative space, that is, an interesting shape supporting the subject, will make the difference between a handsome finished project and an unsatisfying one.

After the drawing is complete, the lace pattern is created. The line drawing is converted into a system of varied textures. Controlling the pattern of the texture, the placement of texture against other texture, plain areas and cut-out areas, we build contrast and the form begins to emerge. Some of the pattern textures that I use are illustrated in the photos throughout the book.

If more than one piece is needed, consider preparing a suite of cuttings. This can be accomplished by drawing a shape across all the pieces that connects them, or by choosing a design element that can be present in all of them. Create templates to help you work quickly and accurately if you are placing one design element in many forms. Hooking templates together in rows of four to six for repeating shapes in background patterns will help you draw the shapes faster and more accurately.

DRAWING

I start by rolling the paper out on a flat hard surface like the floor. I attach a very soft lead pencil to the end of a stick with tape, and walking along the paper in stocking feet, I draw the largest shapes first, creating the design format for the entire work. Then I draw in the particular shapes as simple line drawings. As soon as I can, I prefer to roll the work up and draw these particular shapes within the format on a closer surface such as a table top extended with boards to accommodate the width of the paper. If the scale of these particular elements fits the scale of the format, the design will work, even though you cannot see all of it at once. Draw lightly, and a vinyl eraser will lift changes easily. Usually I roll the paper out again when this part of the process is complete and check the overall design for scale and balance of image and background.

HANGING THE WORK

Hanging the work requires time and common sense. I like to hang the work on a steel conduit pipe with a hole at each end of the pipe, a loop of wire twisted through the hole and a drop line attached to the loop. As I hang the work, I am careful not to let it twist as it rises, as it might tear. Ladders are not practical, as large works are not manageable while climbing. Scaffolding works better.

My idea is that ladders or scaffolds are to be set up once, to install an armature that will stay in place to hang anything whenever one wishes without ever having to leave the floor again. Architects should design churches with such devices in place whenever possible. However, in places where this has not been done, I install a system of drop lines. This consists of an anchor point, a line, some eye hooks, a weight for the end of the line and a ring or hook at the end of the line to attach things to. (See the diagram on page 62.)

For the line, I prefer *braided* nylon cord. It is usually sold as mason's snap line in hardware stores. *Twisted* line does just that, and will bring you many headaches. It is worth the search to find the right cord. Remember that if the end of the cord that is anchored is released, the weight of the installation will pull the line out of the track.

The purpose of the line is to haul. You can attach fishing line to the end of the haul line, but it tangles (and fatigues) and is far more trouble than I care to have. But if you attach a thin fishline to the object, you can move it almost anywhere you wish. If stronger rope is needed, pull it through the system using the haul line in reverse.

Search for the largest possible eye hooks. They have the least resistance. I have been taught that with each edge the cord goes over, the weight that it can hold is divided by ten. That is, 65-pound rope will hold up only 6.5 pounds safely if it has to go around one edge of resistance. Closed pulleys — those used on yachts — are an option. Otherwise, I don't recommend pulleys because the line may come off the track and get jammed in the housing.

All this mechanical apparatus is placed on the inside of the area in the church where the work is to hang, so that they are less apparent. Many buildings have convenient arches or beams across the ceiling. If the apparatus is too apparent, paint it the same color as the background with ordinary acrylic paint.

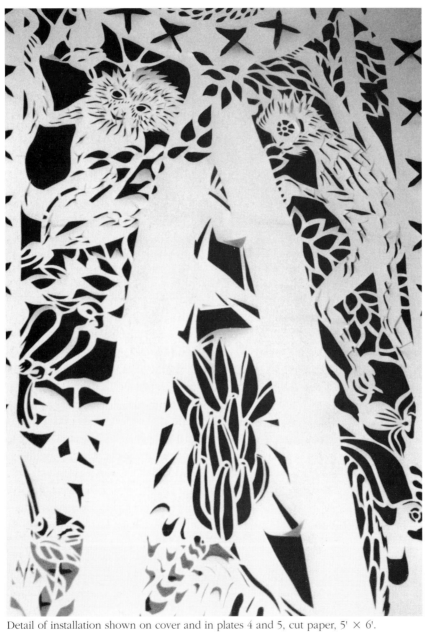

Detail of installation shown on cover and in plates 4 and 5, cut paper, 5' × 6'.

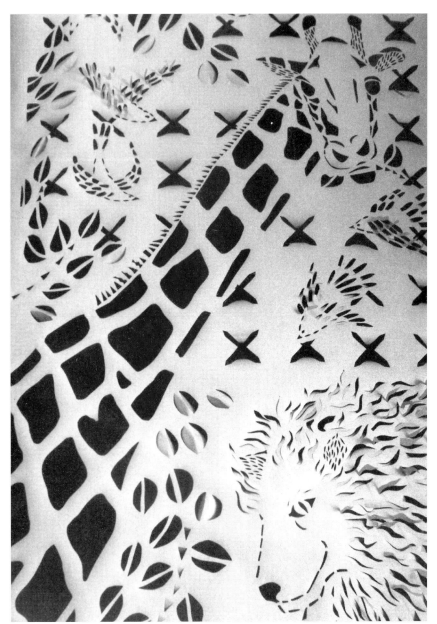

Another detail.

Should it not be possible to install an apparatus, here are some other ideas that have worked. Send drop lines through light wells. (These may even become permanent, depending on the attic structure). Punch a hole through the ceiling to the attic and haul the rope through that. I leave these in place with weights on the end, and pull them up to the ceiling when not in use. Ask someone who practices fly-fishing to cast lines over existing architectural elements. Or someone with a good arm can lob a tennis ball with haul line on it over a beam. The most amusing solution I have heard of came from the imagination of a friend, who suggested helium balloons to hold up some very light work. Huge clear balloons with the work hanging as far as possible below on long cords are delightful, but very temporary.

REPAIRING, STORING, SHIPPING

If it is necessary to repair the work, use white glue and similar paper. Using tape to build bridges or repair the work will age the work, and the shiny surface of the tape is inconsistent with the elegance of the paper itself. If patches will be viewed with light coming from behind them, use rice paper with long fibers for strength and invisibility.

I store and ship the work using the boxes that the paper originally came in, and I place plastic sheeting under the work as I roll it. This keeps the work from catching on itself and helps pad it during shipping.

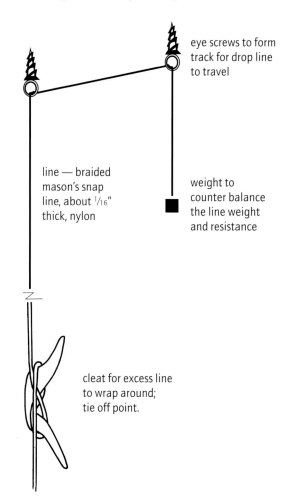

eye screws to form track for drop line to travel

line — braided mason's snap line, about 1/16" thick, nylon

weight to counter balance the line weight and resistance

cleat for excess line to wrap around; tie off point.

6

BEAUTY AND BEHOLDERS

Then I saw a new heaven and a new earth; for the first heaven
and the first earth had passed away, and the sea was no more. And
I saw the holy city, the new Jerusalem, coming down out of
heaven, like a bride adorned for her husband. And I heard a loud
voice from the throne saying, "See, the home of God is among
mortals." And the one who was seated on the throne said, "See, I
am making all things new!"

Revelation 21:1 – 3a, 5

A TREND

Why is it that we find visual art so problematic in the church? Why do
we accept comforting stained glass or banners with slogans, but would
be shocked to have neon splashed across our pulpits?

Perhaps we recall the aesthetics of an itinerant preacher's
revivalist tent, or perhaps the early Puritan and Quaker influences are
the roots of our lack of awareness about the visual elements of wor-
ship. Too often the lack of works of visual art in the place of worship
is a reflection of a lack of interest, rather than a careful creation of
space according to the canons of aesthetic minimalism. Too many
churches reflect a lack of care and a coldness that none of us would
tolerate in our homes.

Yet our reticence concerning the visual arts is a far deeper
issue than historical influence or apathy would suggest. We often sense
visual objects and surfaces as sensual information that holds an emo-
tional charge or content. So our distrust of the visual in the place of
worship might lie more in our fundamental distrust and misuse of the

sensual. It lies also in our difficulty with the polyvalent nature of symbol in a culture of sound bites and easy answers, a culture that claims to know The Truth (its own version, of course). And our popular culture, with its accompanying patterns of taste, acquisition and intolerance of diversity, feeds our ideas about what is appropriate for worship far more than any theological discourse or historical tradition.

Perhaps it is a sign of age that I have lived long enough to begin to see trends and patterns in liturgical planning. Common in the work of providing an environment for worship is a trend that I wish to examine with a critical eye.

It crystallized for me in a recent meeting organized to plan a conference for which I was to help plan the the environment. I had listened for many hours to the radical ideas of the program planners, who outlined difficult and painful processes that would stretch everyone who would attend. In the end, I suggested a design that would reflect the content of the meeting with line, color, texture and pattern that would change for each day of the conference. I was shocked by the question, "Will it be coordinated with the colors of the hotel ballroom?"

As I go from church to church to see what people are excited about as they venture into the visual elements of worship, I see a trend toward arrangements of objects, much as one arranges a home or an office or even a department store window. Decorative elements, such as a swatch of colored material, perhaps some organic elements like dead branches (a favorite during Lent), are added to a room that may itself be problematic, and this work is called "art for environment." The prevailing design criteria seem to be: Does it please the eye? Does it soothe, not jar? Does it decorate, not intrude? Does it recede, not draw attention through its own power to proclaim?

We have confused art with interior design, and art with commercial display. We have substituted this design aesthetic for the demands of art, and have called it "art for worship." Increasingly our worship spaces look like temporary designs that mimic the interiors of expensive department stores or window displays in florist's shops.

As an artist, there are two comments I dread hearing about my art, and that make me suck in my breath and try to hide. The first one

is "It's interesting." The second one is "It's pretty." What these mean to me is that the work is cute, enchanting, like a titillating bleep in a weary landscape. It amuses us, or adorns a space like a handsome jewel on a beautiful hand. It also means the work has no depth, no interior mystery. It relies on dazzling effects, on a romantic seduction of the spirit. In effect, it soothes us, lulls us into a mood of peace that is only surface deep. Have we relegated art to this dusty corner of meaninglessness, asking only that it entertain us?

What "interesting" and "pretty" do *not* mean is that the work is worthy of touching my spirit, moving me deeper into my own laments, my sense of awe or joy, or haunting me so that I must penetrate its meaning. And such art certainly does *not* challenge me, or disturb me — or the worst accusation, distract me — from the verbal content of the liturgy.

MAKING ART IS DIFFICULT

Why is this happening? This simple question has some complex answers. Making art is difficult. It is costly. It takes time, skill, discipline, and above all, connection with the imaginative and creative parts of our souls. It requires a personal commitment to originality. In turn, this demands taking courageous and honest steps toward developing the interior spirit to sustain that originality and its capacity to risk and to possibly fail. Real art for worship has no patterns to follow, no slick tricks, nothing to copy or adapt to your local congregational space. It has no guarantees. Real art rises from interior places that require intense search, many failures, a reaching toward that which has never been done or said in quite that way before. This is its prophetic edge.

The time and materials and spirit it takes to develop such an artist's capacities to dream are extraordinary. What does our church do to support such a person? Do we not need to demand the same level of prayerful, disciplined formation from our artists as we do from our priests or pastors? Is this why there are so few real artists serving the church today?

Or does our difficulty with art rest on an unexamined cultural bias toward words and away from image? Is what we say in liturgy

really more important than what we look at? Is it fair to suggest that hearing clichés in liturgy is the same as seeing visual displays in church that mimic the consumer mentality of our public marketplace? Neither truly serves to nurture the growth of a spirit yearning toward God. Surely we deserve more than a bland diet of attractive arrangements.

There are some things that words cannot adequately say. I have yet to hear words that could contain the quality of light as a storm ends and rainbows dance across the sky, filling my heart with hope. But images can communicate such things to me. I have yet to hear the words capable of describing the glow I see in my lover's face as it lights, greeting me after time apart. Words could never prepare me to understand that my body knows how to give birth to a child, and that these instincts overwhelm rationality. Words do not smell like a small baby's milky breath, or soothe like the gurgle of a chuckling brook, or whisper the rustle of a bird on the wing overhead, or contain the sensation of sun and shade on skin. Our senses hold truths that the Holy One can enter, but that no words alone can penetrate.

Or is the problem one of control? Do we fear change too much? Do we operate from a fear of the imagination and its power to help us change? Do we resist imagination as a place that is worthy of the presence of the holy? Do we insist rather on language and definition, stuffing the wild, free-roaming, creative spirit of imagination into a container of words, pretending this is how we separate orthodoxy from heresy?

Or is the problem laziness in the face of the effort to make art? Or lack of resources, because of the centuries of history that separate artists and the church?

Perhaps it is simply that we have lost our way. We have forgotten the look of materials that bear the mark of their relationship with humans: layering, editing, remaking and reforming until this alchemical process transforms the ordinariness of material into something that contains golden power, shining forth with the power of the relationship between maker and object. We have been too content with the smooth-

edged perfection of mass production. We have let our imaginations be controlled by marketing brochures and catalogs.

Do We Slay or Tame the Dragon?

We need to grow now and turn away from our addiction to perfection — perfect arrangements, perfect spaces — and move into the messiness of risk, of mistakes, of imagination and its whirls of multiple meaning. Perhaps we need to invest more support and faith in our artists to help us find ways to keep our worship lively and full of mystery. Perhaps we might find that these men and women of faith have much more to offer us than pretty things. We need their work, we need it desperately, to help us find our way in this wilderness of violence, despair and the economic powerlessness of class division. We need artists to help us tell not The Truth, but Truth, and once Truth is found, to find the courage to proclaim it to a hungry world.

This is exciting work. What could possibly keep us from this work? No true mythic quest is without trial. For every damsel of delight there is a dragon plotting destruction. As a product of patriarchy, I rush into my closet of weapons, beginning to arm myself with the tools to slay these enemies of life.

But no. Another art piece comes to mind: The icon of St. George slaying the dragon. In the Russian versions of these icons, there is another character in the lower right of the picture. She has a leash on the dragon, and she is taming it. You see, when we truly love, there is no one we must slay. We rather find a way to be in right relationship. Who is to be tamed here? Is it us or the dragon? I don't know. The truth is I am caught in the mystery.

So what is the dragon? It has many names. Laziness. Power. Fear. Ignorance. And what is its weapon? In the art world, we call this weapon "kitsch."

Kitsch

What is kitsch? It is fake art. In the church it is the kind of pseudo-art that we often find in religious bookstores. It lives in sentimental bogs of greeting-card verse. It sells itself in clichés. It clothes itself in popu-

larity-of-the-moment, in quick fixes, in empty cartons giftwrapped in promises of the heaven of no cellulite or a new nose or larger or smaller breasts, or great commissions, or yes, even a published book!

Kitsch asks us not to listen. It tells us not to think. It does not invite a relationship. It simply smothers us in slickness. It does not invite freedom, because it is too busy telling me what I am to believe, or feel, or buy. It is not about sharing. It substitutes titillation for quest. It is about atrophying our capacities to think and to imagine. Kitsch is not about life. It is about anesthetizing. It is about addiction. It is a lie.

How does one put a leash on this dragon? Is this dragon to be slain or encircled with compassion and discipline? When you face decisions for the Advent and Christmas seasons ahead, just how will you deal with the evergreen tree and wreaths that you have always had in church? Are they kitsch? How will you avoid decorating yourself like the shopping malls and the other commercial enterprises that strive to define this incarnational experience of God dwelling with us?

OTHER TYRANNIES

There are other dragons out there to be tamed. Tyranny, for one. This dragon is on both sides, the art world and the church world. Those who define liturgy by the yardstick of comfort will blow fire at our tentative efforts to find new forms for the gospel. "Out, out," they scream, "with your distractions, your wasted time, your costly and squandering use of materials and human effort. How much better to use this money to feed the poor!" (See John 12:5.)

Those who define art by the market will be appalled at our lack of interest in commodity, in sales, in permanence. Their weapons are often critical analysis that cannot accept work from the heart as worthy, that is frightened by art that has a multitude of creators instead of one superstar.

Within the world of academia, the problem becomes rarefied. Here I need not tell you about the trivialization of anything not published, not researched, not recognized by the authorities. Visual art, if it

is taught within our seminaries at all, is usually taught as art history, highlighting art of the past. To suggest that my research as an artist is something led by my hands, not my head, that the making of the work is my primary source of raw knowledge, that the image might be the primary document, will send most academics into other fields of inquiry, dismissing this work with mere amusement.

I find I am not as interested now in evaluating my art and the art of others in terms of a formal critique of the picture plane. While I find useful the discussion of work from a perspective of line, compositional elements, edge treatments, textural surfaces and all the other points of comparison, it is not here that I find meaning. Rather than this intellectualization, I am intrigued with how the work lives. I find this out by way of relationship. What does this work bring up for me, I ask. Memory? Feelings? A sense of mystery? In other words, how do I experience this work? What can I learn about myself through observing how I view this work? It may be useful to think of this as a relational aesthetic, a better version of "I know what I like and what I don't like."

School taught me well to dissect, to analyze, to evaluate, to order, organize and orate my points of prejudice to make them seem justified and judicial. But these acrobatics do not serve to liberate my thinking. As an artist, I am renewed by standing in the center of the timelessness of ecstasy, by soaring on the kite tails of my imagination, by dreaming, by wandering through thinking that moves spontaneously between mountains and mints, between wind and the smells of new wine, the rustle of dry fall leaves and the tinkle of wind chimes among my ideas. I am trying to say that the whole of it interests me as much as the parts that the academy seems to prefer. The holistic experience of all of life, without segmenting it, is another path to my work and research. So I cultivate the sensate as part of each idea. I dwell on the moment's gift as well as the flow of an idea. Interruption becomes being pulled into someone else's expectations without being able to incorporate those expectations into my own process.

Art and Pastoral Care

Finally, I would like to approach the question of permanent and temporary art. I have been trained to produce art with an eye to permanence (assuring the investor, one presumes, that the purchase of my art is worthy of the money spent, expecting it to appreciate to the investor's benefit). Art in worship can have another meaning.

Think about it. Would you hear the same homily at each service? Would you wear the same clothes, sit in the same place, or breathe the same way each service? Of course not. I would argue that nothing is static in worship, and when it is, we grow so familiar with it that we no longer see or hear it. And the purpose of ritual is not to make it go away!

We have a problem with visual art. It is thought of as too expensive, too time-intensive to be temporary. Personal histories and personalities are stored in every stitch and stroke. So we store and bring out the same banners year after year. What do we miss?

By working with temporary materials, costs are far less. By working with the community to make and install the work, the amount of time spent is usually equivalent to the number of human hours spent creating a special service of music. We are a visual choir, creating original work. By demanding that the work change, we give room to new creative thoughts, and best of all, we are able to bring the Word of God freshly to each community. What is permanent is the record we keep in slides or scrapbook of each installation that we do.

When the work is put up, must it come down for special services such as weddings? Most churches have a policy that the art is not removed until its time is up.

Who owns the art? This becomes a painful question when people move on. There is no easy answer, so it's best to clarify this when the work is made and installed.

How do you keep each other from becoming discouraged or overwhelmed? This process of creating liturgical art is very demanding. There are no short cuts, no easy solutions. I need a group of people who are committed to hearing me as I fatigue or become doubtful. This is a pastoral act of friendship. The artist also must be freed from having to deal with justification or outrage about the work. Contrary to

popular thought, this kind of criticism undermines creative work. It does not free us to imagine, but rather arms us to react. When this criticism happens (and it does) this is a pastoral counseling issue, not an artist's issue. Our work is to make, present, document and interpret the work. How others react is a different issue, one we artists may not be equipped to approach or resolve.

DREAM DREAMS

It is my hope that you will dream dreams and see visions that I cannot imagine. It is my hope that you will send me pictures or comments about what you have accomplished, and that you will find ways to share this with others also. Please write to me:

<div align="center">

Nancy Chinn
c/o Pacific School of Religion
1798 Scenic Ave.
Berkeley CA 94709

</div>

LOCATIONS AND PATRONS OF WORKS DEPICTED

Cover photo, plates 4 and 5, photos on pages 27, 32, 56, 60, 61: Commissioned by Presbyterian Women's Conference, "Whose World Is It?" Ames, Iowa, 1991.

Plate 2, 3: Commissioned by Presbyterian Association of Musicians, Montreat, North Carolina, 1997.

Plates 6, 7 and the photo on page 22: Commissioned by First Presbyterian Church, Berkeley, California, Advent/Christmas, 1995.

Plates 8, 9: Commissioned by Presbyterian Women's Conference, "You Are My Beloved," and the "Year with Africa" (mission), Ames, Iowa, 1994.

Plate 9: Banners here used in First Congregational Church, Berkeley, California. Installation commissioned by the Pacific School of Religion, for Earl Lectures: "A Multiethnic Look at the Life of Jesus," 1995.

Plate 10, 11: Commissioned by the Pacific School of Religion, for Earl Lectures: "Judaic/Christian/Islamic Relations," 1988.

Plates 12, 13, 14, 15, 16, 17 and 18 and photos on pages 28, 29: First Presbyterian Church, San Anselmo, California, 1985.

Plate 19 and photos on pages 24, 25: Commissioned by First Presbyterian Church, San Mateo, California, for concert "Behold! The Light!" 1988.

Plate 20: First Presbyterian Church, San Anselmo, California, Palm Sunday, 1983.

Plates 21, 22: Grace Episcopal Cathedral, San Francisco, California, AIDS Awareness Week, 1988.

Plates 23, 24, 25: First Congregational Church, Berkeley, California, Pentecost, 1987.

Plates 26, 27, 28, 29: Studio preparation of banners in plates 8, 9. Studio donated by Fruitvale Presbyterian Church, Oakland, California.

Plates 30 and 31: Another part of the installation for the Earl Lectures in 1995. See also plate 9.

Plates 33 and 34: Commissioned by World Council of Churches for conference "Breaking the Chains that Bind," Hungary, 1997.

Plate 35 and photo on page 20: Commissioned by First Presbyterian Church, San Anselmo, California, 1980.

Plate 36 First Congregational Church, Berkeley, California, commissioned by the Pacific School of Religion for Earl Lectures, "Equipping The Church for the 21st Century," 1997.

Plates 38, 39: Commissioned by St. Mark's Episcopal Cathedral, Minneapolis, Minnesota, 1993.

Plate 40: Detail of "For the Healing of the Nations," commissioned by Yerba Buena Art Center, San Francisco, 1992.

Plate 1 and photos on pages 30 and 31: Commissioned by Grace Cathedral, San Francisco, California, 1989, 1995, 1998.

Photos on page 19: First Presbyterian Church, San Anselmo, California, Lent and Easter 1986.